IMAGES
of America

LAKE CHAMPLAIN
MONUMENTS AND
MEMORIALS

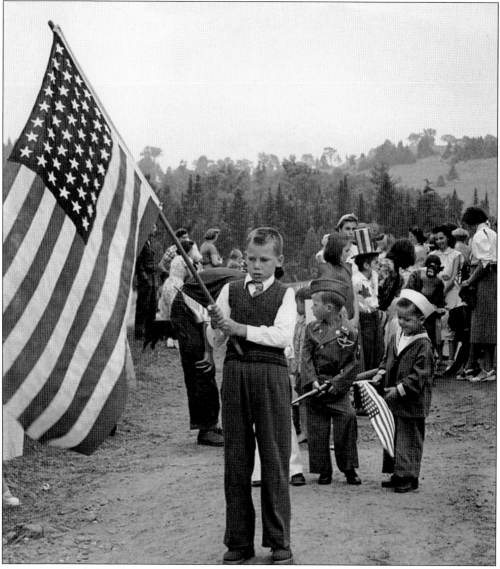

Verner Reed took this photograph of boys in Danville, Vermont, in 1952. The image shows various townspeople in patriotic gear but focuses on a young boy holding the American flag and two younger boys in military costumes holding smaller flags. Presumably a Fourth of July celebration, the photograph was part of the exhibit A Changing World: New England in the Photographs of Verner Reed, 1950–1972. (Courtesy of the Pratt family.)

ON THE COVER: The George Satterlee Hose Company of Fort Edward in Washington County celebrates its 65th anniversary on May 27, 1938. (Courtesy of the Pratt family.)

IMAGES
of America

LAKE CHAMPLAIN
MONUMENTS AND
MEMORIALS

Anastasia L. Pratt

ARCADIA
PUBLISHING

Published by Arcadia Publishing
Charleston, South Carolina

Printed in the United States of America

Library of Congress Control Number: 2023939489

For all general information, please contact Arcadia Publishing:
Telephone 843-853-2070
Fax 843-853-0044
E-mail sales@arcadiapublishing.com
For customer service and orders:
Toll-Free 1-888-313-2665

Visit us on the Internet at www.arcadiapublishing.com

*To my sister Nicole, who has been with me for
the whole journey. Love you. Always.*

CONTENTS

ACKNOWLEDGMENTS

I am blessed to call the Champlain Valley home. From my childhood, which feels like it was equal parts Vermont and New York, I learned to love the beauty of this place and have found myself always returning to the lake and the mountains around it. That journey has been made ever better by the amazing historians, librarians, archivists, and lovers of the past who have helped me to uncover parts of the history of this place. I am also grateful to the many friends who offered suggestions about monuments and markers that should be included here and waited patiently as I took yet another photograph. Unless marked otherwise, the images come from the personal collection I inherited from my ancestors, who compiled an impressive number of photographs and photo postcards of the Champlain Valley and its history. I hope that this collection, though it is incomplete, shows my love of this place and its people.

Introduction

With a shoreline of more than 587 miles, Lake Champlain is connected to a system of tributaries throughout a basin of 8,234 square miles. For more than 10,000 years, humans have recognized the wonderful resources of the Champlain Valley. When the glaciers that covered this land retreated, herds of wild animals—most notably elk, caribou, and mastodon—moved in, attracted by the nutrient-rich plants. Soon after, the first people followed, attracted by the same natural diversity that promised sustenance. From the freshwater wetlands to the complex aquatic ecosystems and wildlife habitats the basin provided life for those earliest people and continues to offer the same wealth of opportunities to its residents. As the Lake Champlain Basin Program explains, "the history of the region has been inseparable from the lake."

Samuel de Champlain plays an important role in that history. After he explored the region in 1608 and 1609, Champlain established the first permanent European settlement in Quebec City. From that point, north of the current US-Canadian border, European colonists began moving south, following the network of rivers, streams, ponds, and lakes that would provide a life for them. Soon after, settlers began moving north into the valley as well. Bringing traditions from their French, English, Dutch, and Scottish forebears, these settlers established communities that continue to exist today. As mills and iron mines grew, French-Canadian and Irish immigrants joined them. While tensions between indigenous communities and settlements of European-descended people rarely percolated into violence locally, the two groups have not had an idyllic relationship. Discrimination against Native Americans riddled encounters throughout the 19th century, as did prejudice against immigrants, including those who came to the Champlain Valley as part of refugee resettlement programs, bringing vibrant Asian and African cultural traditions with them.

Vermont's official recognition of the Abenaki in 2011 and 2012 were watershed moments for local indigenous peoples, though that recognition was long in the making, considering that the Native history of the region began almost 13,000 years ago. In New York, the Six Nations—the Mohawks, Senecas, Onondagas, Oneidas, Cayugas, and Tuscarosas—live at the edges of the valley, in lands inhabited by their ancestors and, in some cases, promised as part of resettlement treaties. Their cultural heritage lives on, as does that of the Abenaki, in vibrant communities that share the wisdom of the past through schools, ceremonies, and museums. Often, the indigenous peoples have led the way in protecting the natural environment of the Champlain Valley, spearheading local actions to preserve and honor this place.

And that protection is essential. Permanent settlement in the Lake Champlain Basin, with its influx of people and industries fueled by the many waterways and made possible by railroads and lake travel, has caused water-quality issues and changed the landscape in a multitude of ways. The creation of Adirondack Park in 1894, with its hallmark of "Forever Wild," was an early attempt to preserve the natural beauty of the valley and protect its woodland ecology. The 1932 designation of the Green Mountain National Forest furthered that quest. However, more was still necessary, so in 1972, the Clean Water Act was passed and continues to offer a means of protecting the lake

around which the valley is centered. In more recent years, efforts to clean the lake have taken the form of addressing the preponderance of zebra mussels, an invasive species of mollusks that negatively affects the lake's ecosystem and the cultural artifacts that live in the lake's waters; the need to remove more than 100,000 tons of polychlorinated biphenyls (PCBs) in Cumberland Bay, lasting reminders of the wood products industries along the lake; and the international agreement to improve the water quality of the Missisquoi Bay by reducing pollution entering the lake.

Attempts to protect the cultural landscape of the region have occurred at the same time, often spurred by local efforts to preserve the natural environment. The Lake Champlain Preserve was established in 1986, bridging the gap between nature and history. Similarly, the Lake Champlain Basin Program (LCBP)—established in 1991 to coordinate and fund efforts to benefit the basin's water quality, fisheries, wetlands, wildlife, recreation, and cultural resources—and the Champlain Valley National Heritage Partnership (CVNHP), approved by the National Park Service in 2011, work to preserve and celebrate local history in all its forms. For the last several years, they have worked with local municipalities to erect wayside markers that honor specific people, places, and events and educate residents and visitors about the natural wonders and historical significance of the Champlain Valley. A multitude of museums, historical societies, heritage organizations, and historians throughout the valley further that work daily.

Monuments and historic markers throughout the region take on many forms, traditional and modern. While the wayside markers created by the LCBP and CVNHP tend to be larger installations, with words and images, that are highly specific to an individual location, other, smaller historic markers have been installed as part of Vermont's Roadside Historic Site Marker program and by local groups in New York. Local monuments range from gravestones and statues to entire buildings and parks, with outside art more recently coming to offer a new look at the past.

In order to offer a glimpse of every county in the Champlain Valley, as defined by the LCBP, this book is organized into thematic chapters, each showcasing historic markers and monuments that honor a different facet of life. The first, Celebrations and Commemorations, looks at the larger-than-life festivals, with their parades, monuments, concerts, and ceremonies. A Working Life, in contrast, focuses on the markers dedicated to ordinary life and to the jobs, industrial and agricultural, of the region. The Cultural Landscape prioritizes markers that significantly recall the built environment, while Local Legends shines a light on our myths and hometown heroes. The book ends with Solemn Remembrances, which takes a close look at the markers and monuments built to honor those no longer with us. This organization allows the reader to think about the reasons markers are erected and, through the photographs, visit a wide swath of the Lake Champlain region.

One

CELEBRATIONS AND COMMEMORATIONS

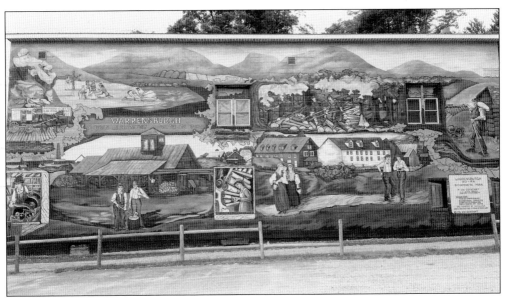

With Dick Doux and Jim Cockcroft, artist Eva Cockcroft created this mural to commemorate Warrensburg, New York. Part of the nation's bicentennial celebrations, the mural offers a vision of the area's earliest indigenous settlers, as well as its later settlement by European-Americans. In 2000–2001, the Hamlet of Warrensburg Historic District was listed in the State and National Registers of Historic Places, offering the largest historic district in the Adirondack region.

Each year, the town of Chazy, New York, celebrates its history in the Chazy Old Home Days festival. Activities range from an antique car show to a barbecue and culminate with the crowning of a king and queen. In 2008, Ronnie and DeeDee Brown were crowned by the preceding year's royalty, Donald "Bucket" and Betty Trombly. (Photograph by Rachel Moore, courtesy of the *Plattsburgh Press-Republican*.)

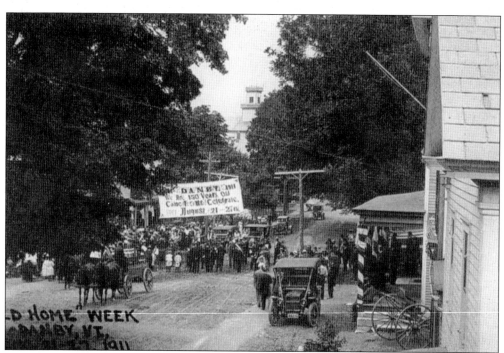

In 1911, led by Rev. W.A. McIntire, Danby, Vermont, celebrated its 150th anniversary with a week of reunions and special events. Visitors from throughout the Northeast attended the festivities, coming from far and wide to celebrate their hometown and their families. At the end of the week, town members dedicated a fountain presented by the Improvement Society. (Courtesy of the Danby-Mt. Tabor Historical Society.)

Earlier generations of historic markers, like this one from Fort Ann, New York, remember wars and violence on the part of indigenous peoples. Skewed to the perspective of the settler and colonizer, these markers forget that people lived in these places before European arrival.

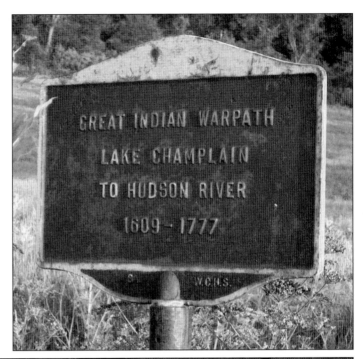

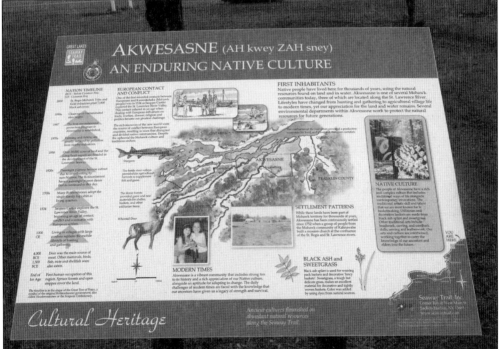

Thankfully, newer markers, like this one from Franklin County, New York, recall the lasting legacy of indigenous cultures and offer a more balanced vision of the past. Akwesasne, known as the "land where the partridge drums," is inhabited by Mohawks who are proud of their commitment to the ancient Mohawk territories and resources, the aboriginal rights of their community, and their Kahniakehaka (Mohawk) Nation.

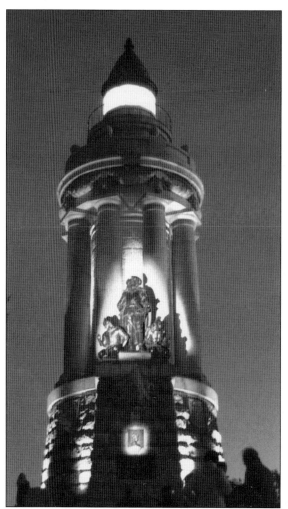

The Champlain Memorial Lighthouse was built around an existing lighthouse to commemorate the 300th anniversary of Champlain's arrival in North America. Carl Auguste Heber's statue of Samuel de Champlain, flanked by an indigenous person and a French voyageur, graces the lighthouse, and *La France*, a bronze bust sculpted by Auguste Rodin, lies below. During the quadricentennial celebrations, the lighthouse was the site of many joint New York–Vermont ceremonies. (Photograph by Jack Laduke, courtesy of the Clinton County Historian's Office.)

The Vermont Abenaki Artists Association remembers tribal customs and traditions while simultaneously promoting indigenous artists and their art. Since 2009, when it worked to contextualize quadricentennial events, the group has been extremely active, offering presentations, art shows, and heritage festivals throughout the Champlain Valley. This 2022 offering highlighted the intersection of Abenaki arts and environmental issues. (Courtesy of the Vermont Abenaki Artists Association.)

Water Is Life
ABENAKI FREE ARTS

Music, Storytelling, and Artmaking

Learn about Abenaki tribal customs, traditions, and the intersectionality between Abenaki arts and environment issues. This art program explores the *Nebizun: Water is Life* traveling museum exhibition and the 50th Anniversary of the Clean Water Act.

In 2009, Catholic churches throughout New York, New England, and Quebec recalled the ways in which their parish histories are related to the legacy of Samuel de Champlain's voyages. St. Mary's Church in Champlain, New York, celebrated a mass, complete with the local chapter of the Knights of Columbus, to rededicate the statue of Champlain that sits beside the church building. (Courtesy of the Clinton County Historian's Office.)

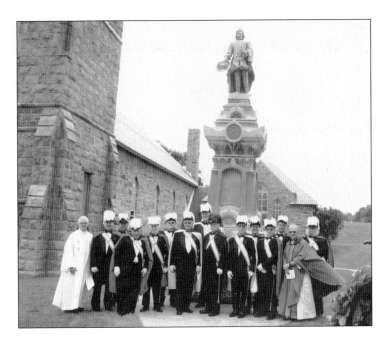

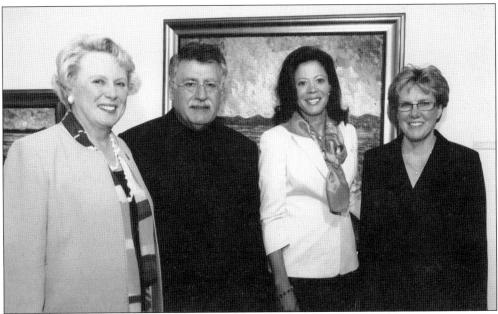

Celine Racine Paquette (left) served as the vice chair of the New York State Hudson Fulton Champlain Commission. As part of her work, she helped to unveil interpretive paintings by Canadian artist Samir Sammoun (second from left). They are joined here for the unveiling of his work at SUNY Plattsburgh with first lady of New York Michelle Patterson (second from right) and Sammoun's wife, Yvette. (Courtesy of the Clinton County Historian's Office.)

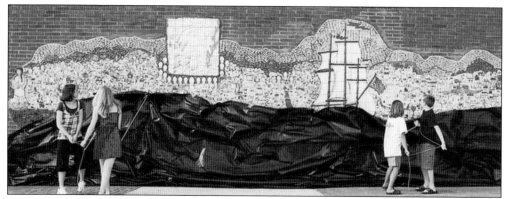

Artist Sue Young, along with Bucky Seiden, Sandy Morse, and Clinton County historian Anastasia Pratt, worked with students from the county's seven school districts to create the *Clinton County History Through the Eyes of Its Children* mosaic, shown here at its unveiling in August 2009. The mosaic offers a vision of local history from indigenous peoples through the 19th century. (Photograph by Michael Betts, courtesy of the *Plattsburgh Press-Republican*.)

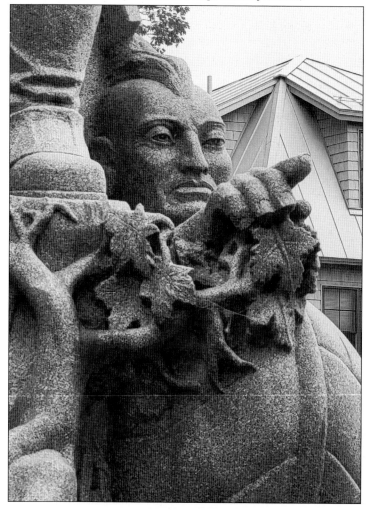

This close-up of the Samuel de Champlain monument given to the town of Isle la Motte by the State of Vermont in 1968 focuses on the indigenous person who sits in the canoe at Champlain's feet. This man is clearly the guide, pointing to the route ahead. Sadly, not much is known of the individuals who helped Champlain on his journeys.

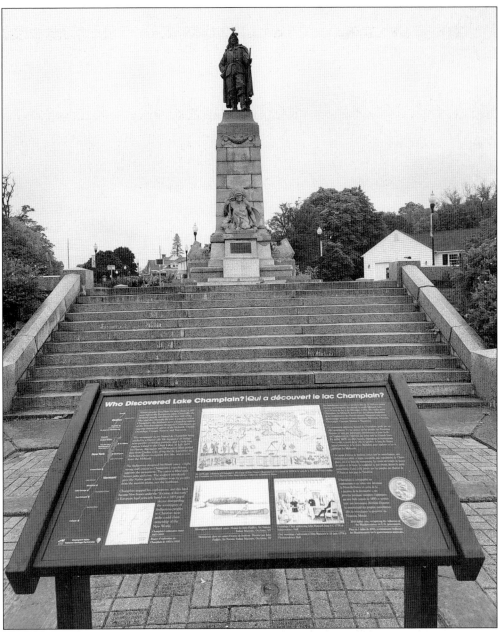

All along Lake Champlain, from Quebec City to Crown Point, New York, monuments and markers celebrate Samuel de Champlain's voyages. Often, these markers proclaim Champlain as the person who discovered this land and lake, praising him as a colonizer and explorer. Yet, Champlain was not the first person to live on this land or to see this lake. When indigenous peoples are included in these monuments, they are a stylized version of "Indians," bearing little resemblance to those who lived locally. This statue, for example, offers a man who crouches in a Western war bonnet and clothing not at all accurate for any of the local tribes. In Plattsburgh, where this statue was dedicated in 1959 for the 250th anniversary of Champlain's voyages, citizens working with the Plattsburgh City Council developed a wayside marker to contextualize the history of the region and its earliest inhabitants. Unveiled in 2020, the marker is an important addition to the park.

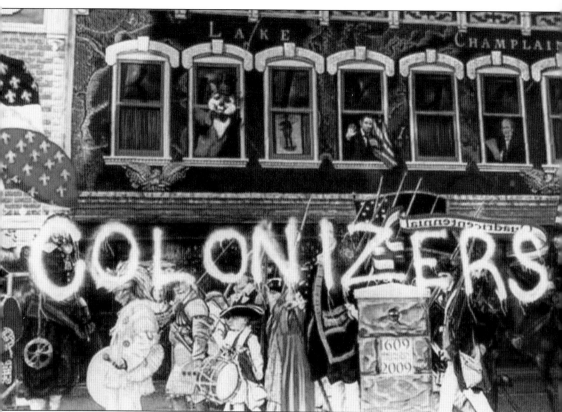

Protests over inaccurate, one-sided portrayals of history have taken many forms. In Burlington, Vermont, those who opposed the installation of Québecois artist Pierre Hardy's 2012 mural known as *Everybody Loves a Parade* made their displeasure known through spray-painting "colonizers" and "off the wall" across sections of the 124-by-16-foot mural. Made of 50 panels and featuring more than 185 people—including Champlain, Vermont senator Bernie Sanders, and Burlington mayor Miro Weinberger with his daughter on his shoulders—the mural singularly lacks diversity; most, if not all, of the figures included are white. Vandalism progressed to protests, and in 2020, the Burlington City Council voted to remove all 50 panels of the exhibit and store them at the Burlington International Airport by 2022, though the work was accelerated and completed in August 2020. A restored version of Gina Carrera's *Rainforest* (1992), which was covered by the 2012 installation, was reinstalled on the Leahy Way wall, near Church Street.

A founder of the Iroquois Confederacy, or Haudenosaunee, Deganawidah said on planting the Tree of Peace, "Our strength shall be in union, and our way the way of reason, righteousness, and peace." Ray Tehanetorens Fadden erected this and other monuments on his property in Onchiota, New York. Now the site of the Six Nations Iroquois Cultural Center, Fadden's work to remember indigenous life and history continues. (Courtesy of David Fadden.)

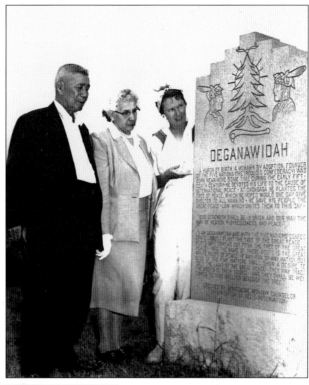

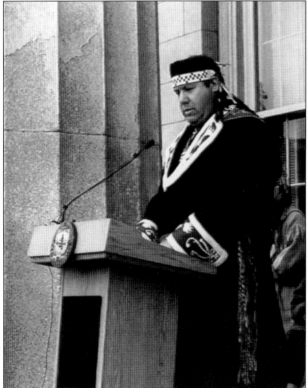

Dan Stevens, chief of the Nulhegan Band of the Coosuk-Abenaki Nation, speaks from the Vermont State House in 2011, after Gov. Peter Shumlin signed bills granting state recognition to the Elnu Abenaki and Nulhegan Bands. To use Stevens's words, "We are the Nulhegan Tribe; the Memphremagog Band; the Northern Cowasuk Indians. We have lived here . . . from time beyond memory."

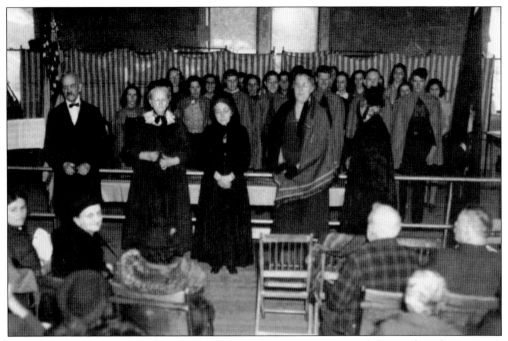

In 1942, Marshfield, Vermont, celebrated its 150th anniversary. From left to right, Alvi T. Davis, Lillian Davis, Ella Lilley, Lou Carpenter, and Maude Davis stand between a chorus and the gathered audience at the Knights of Pythias Hall. With rituals based on the Greek legend of Damon and Pythias, the fraternal organization was devoted to strict morality, absolute truthfulness, honor, and integrity.

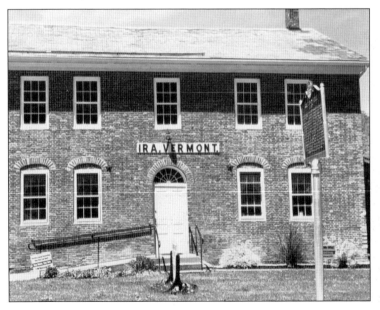

Named for the brother of Ethan Allen, Ira, Vermont, is a small town in Rutland County. Since 1800, a meetinghouse or town hall has stood on this land, donated by Thomas and Benoni Collins. The oft-renovated building, which witnessed church services, town meetings, and school lessons, was restored in 2001 and continues to be used. A historic marker was added to the site in 2020.

Throughout 1976, Americans celebrated the bicentennial. That year, Moscow, Vermont, offered a Fourth of July parade with an anniversary theme. The parade was very brief—the owner of the market, postmaster, and unofficial mayor, Peter DeCelle dressed in black like a judge, marched behind a bicentennial banner, leading a group of citizens about 200 yards past his store and back again.

The Fourth of July parade in Burlington, Vermont, was a longer affair, with floats, bands, and many waving flags. Here, Gloria Pratt holds her daughter and watches the parade along with her nephew Roger. Everyone born in 1976 in Vermont was given special red, white, and blue sashes to indicate that they were "bicentennial babies." The special bicentennial flag is a sign of the pride Vermonters took in that history.

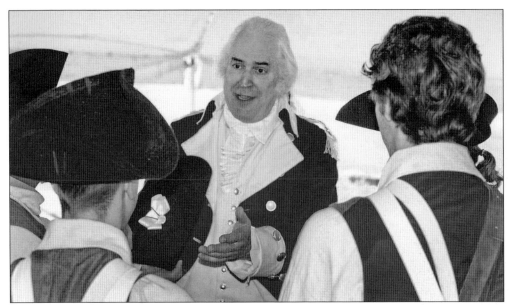

Dan Malissa, an actor from Philadelphia, portrayed Gen. George Washington during a special 2008 reenactment of the 1775 victory for American forces. Washington's appearance at the event was anachronistic: the Americans were led by Ethan Allen and Benedict Arnold, the latter of whom defected to the British in 1780. (Photograph by Lohr McKinstry, courtesy of the *Plattsburgh Press-Republican*.)

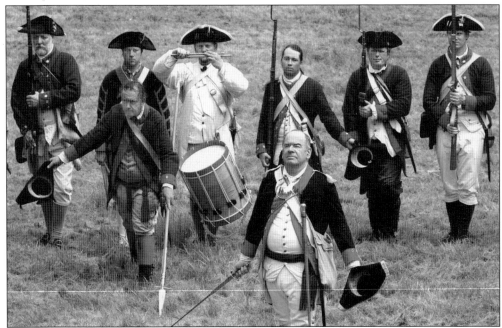

This August 2009 reenactment was presented at the Crown Point State Historic Site by Col. Mark Hurwitz (shown here) and other members of the Brigade of the American Revolution. The Fort at Crown Point was held by the British after the French and Indian War but quickly surrendered to Capt. Seth Warner and his Green Mountain Boys in 1775. (Photograph by Alvin Reiner, courtesy of the *Plattsburgh Press-Republican*.)

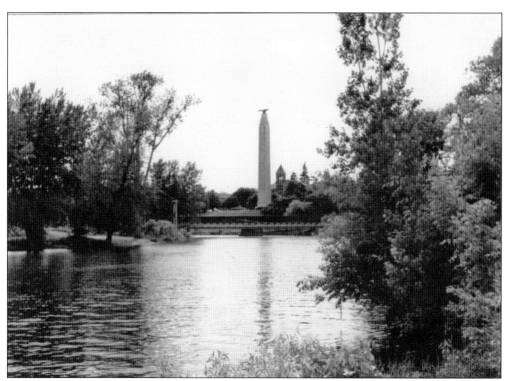

Situated on the Saranac River, the Macdonough Monument celebrates the history of Thomas Macdonough, who led US Navy forces to defeat the British during the Battle of Plattsburgh in 1814. The 135-foot-tall obelisk designed by John Russell Pope was dedicated in 1926. The central point of Battle of Plattsburgh commemorations, this monument makes history visible with interior interpretive panels and exterior markers. (Courtesy of the Clinton County Historian's Office.)

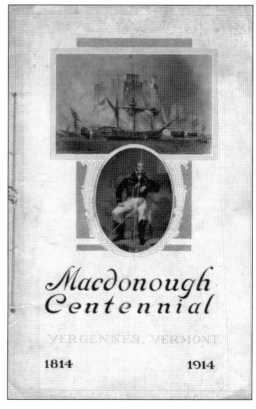

One hundred years after Macdonough's defeat of the British, the citizens of Vergennes, Vermont, remembered the role of their town in the War of 1812. The USS *Saratoga*, along with several other ships, was built in Thomas Macdonough's shipyard on Otter Creek. This fleet of warships, though small, helped to defeat the British on Lake Champlain.

The 200th anniversary of the Battle of Plattsburgh brought a multitude of commemorative activities. One hardy group reenacted the march south, with stops at each of the locations where skirmishes between the British and Americans occurred. Here, men in period dress and the home's owner pose next to the Scott Home, which served as the British headquarters for General Prevost prior to the battle.

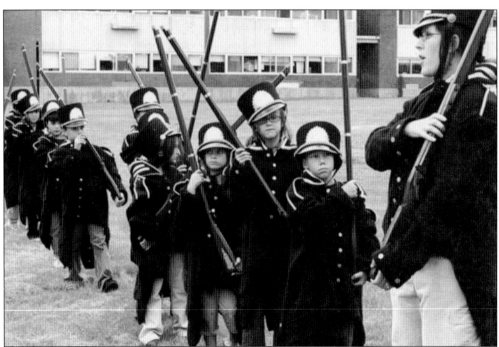

Students in the Beekmantown Central School District remembered the Battle of Plattsburgh in September 2008, when teachers from the district's elementary, middle, and high schools brought their students to the Cumberland Head Elementary School campus to share what they learned. Here, students led by seventh-grade English teacher Kendi Rankin (right) try their hand at a reenactment. (Photograph by Kelli Catana, courtesy of the *Plattsburgh Press-Republican*.)

Martin Henry Freeman, an African American educator and abolitionist, was born in Rutland, Vermont, and graduated from Middlebury College in 1849. Freeman went on to become a professor at and president of the Allegheny Institute in Pennsylvania. Believing that freed slaves should return to Africa, he emigrated to Liberia in 1864. Designed by Mark Burnett and carved by Don Ramey, this statue honoring him was installed in 2020. (Wikimedia/Whoisjohngalt.)

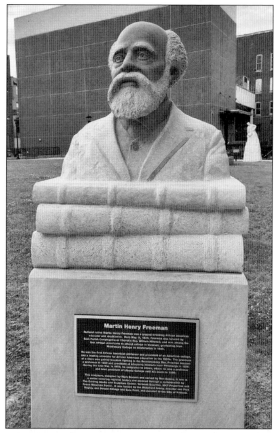

In keeping with the region's long military history, reenactors participated in a military timeline at the Battle of Plattsburgh Association campus in Plattsburgh, which is located on the former Plattsburgh Air Force Base. Participants in the May 2008 event represented 400 years of service and offered demonstrations of their weaponry. (Photograph by Rachel Moore, courtesy of the *Plattsburgh Press-Republican*.)

Given economic life by the mining industry, the town of Moriah was established in 1808. Two hundred years later, in April 2008, members of the Moriah Town Council (from left to right) former town supervisor Walt Rushby, Councilman Anthony Havish Jr., Moriah supervisor Tom Scozzafava, Councilman Richard Carpenter, and Councilman Thomas Anderson reenacted the first town board meeting. (Photograph by Bethany Kosmider, courtesy of the *Plattsburgh Press-Republican*.)

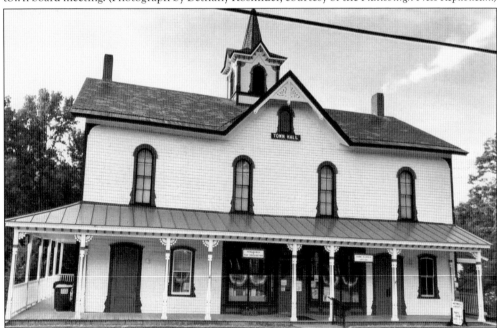

Standing on School Street, Pawlet Town Hall offers a shining vision of a Vermont town that affirms its commitment to diversity and inclusion. Chartered in 1761, the town stands for "kindness, understanding, neighborliness, peace, tolerance, and respect for and toward all. We stand against racism, bigotry, discrimination, prejudice, violence and hatred in all of their forms."

Clinton County historian Addie Shields (right) was named grand marshal of the Mooers bicentennial parade in 2004. Accompanied here by Mooers town historian Carol Nedeau, Shields was a fierce advocate of local history, working tirelessly to teach others about life in Clinton County, New York, from its foundation in 1788. (Courtesy of the Clinton County Historian's Office.)

Queensbury, New York, is home to a famous wooden roller coaster that began its life in Ontario as the Cyclone and is now known as the Comet. Torn down in 1989, Charlie Wood, owner of the Great Escape, bought the coaster and eventually rebuilt it locally. In 2009, American Coaster Enthusiasts recognized that history with this plaque.

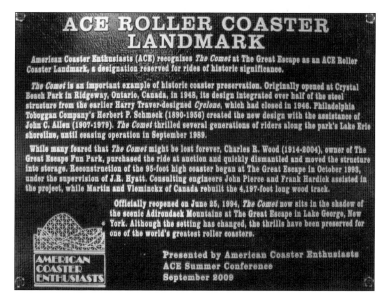

ACE ROLLER COASTER LANDMARK

American Coaster Enthusiasts (ACE) recognizes The Comet at The Great Escape as an ACE Roller Coaster Landmark, a designation reserved for rides of historic significance.

The Comet is an important example of historic coaster preservation. Originally opened at Crystal Beach Park in Ridgeway, Ontario, Canada, in 1948, its design integrated over half of the steel structure from the earlier Harry Traver-designed Cyclone, which had closed in 1946. Philadelphia Toboggan Company's Herbert P. Schmeck (1890-1956) created the new design with the assistance of John C. Allen (1907-1979). The Comet thrilled several generations of riders along the park's Lake Erie shoreline, until ceasing operation in September 1989.

While many feared that The Comet might be lost forever, Charles R. Wood (1914-2004), owner of The Great Escape Fun Park, purchased the ride at auction and quickly dismantled and moved the structure into storage. Reconstruction of the 95-foot high coaster began at The Great Escape in October 1993, under the supervision of J.R. Hyatt. Consulting engineers John Pierce and Frank Hardick assisted in the project, while Martin and Vleminckx of Canada rebuilt the 4,197-foot long wood track.

Officially reopened on June 25, 1994, The Comet now sits in the shadow of the scenic Adirondack Mountains at The Great Escape in Lake George, New York. Although the setting has changed, the thrills have been preserved for one of the world's greatest roller coasters.

Presented by American Coaster Enthusiasts
ACE Summer Conference
September 2009

25

In 1822, the Glens Falls Feeder Canal was built to divert water from the Hudson River to the Champlain Canal. Widened in 1832 to accommodate boat traffic, the Feeder Canal was listed in the National Register of Historic Places in 1985 and has been preserved, promoted, and maintained by the Feeder Canal Alliance since 1987.

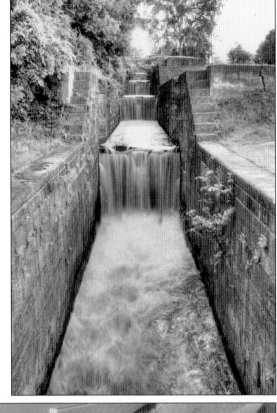

Closures, too, are commemorated. When the Plattsburgh Air Force Base closed in 1995, local residents gathered on the Oval for the decommissioning ceremony. The history of the installation was shown in photographs, timelines, and certificates inside the buildings. Much of that history is now recalled by the Plattsburgh Air Force Base Museum.

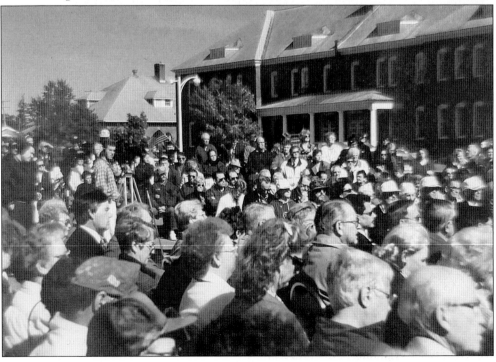

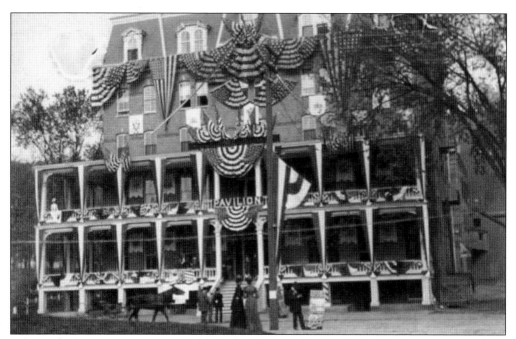

When Adm. George Dewey returned to Montpelier, Vermont, after a tour celebrating his victory in the Spanish-American War, his hometown declared October 12, 1899, Dewey Day. Here, the Pavilion Hotel is decorated with flags and bunting to celebrate the hero's return. Today, this building houses the Vermont History Museum.

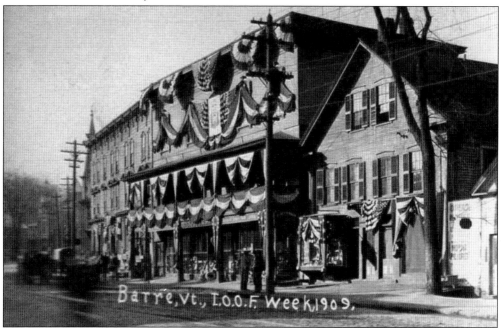

The Reynolds Block of Main Street in Barre, Vermont, is decorated to celebrate the International Order of Odd Fellows Week in 1909. A fraternal organization dedicated to promoting the principles of friendship, love, truth, faith, hope, charity, and universal justice, Vermonters were able to join chapters of IOOF beginning in the 19th century.

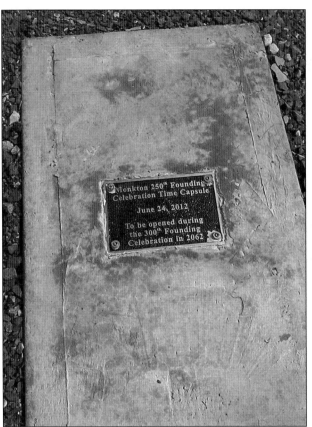

Chartered in 1762 and organized as a town in 1786, Monkton, Vermont's, history is told through the Monkton Museum and Historical Society, which now inhabits the former Monkton Town Hall, built in 1859 and listed in the National Register of Historic Places. Residents have also chosen to preserve some local history through this time capsule meant to be opened during the 300th anniversary. (Wikimedia/Dismas.)

Although she was born in Virginia, the poet Ruth Stone spent much of her life in Goshen, Vermont, where this historic marker, complete with a poem, is located. From here, she raised her children and became a poet of some renown, teaching at a host of universities around the country. In 2007, Stone was named the Vermont state poet; two years later, she was a finalist for the Pulitzer Prize.

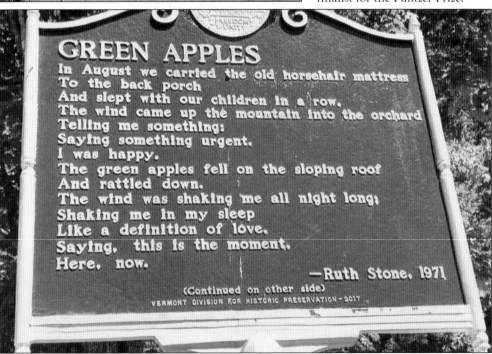

GREEN APPLES
In August we carried the old horsehair mattress
To the back porch
And slept with our children in a row.
The wind came up the mountain into the orchard
Telling me something:
Saying something urgent.
I was happy.
The green apples fell on the sloping roof
And rattled down.
The wind was shaking me all night long;
Shaking me in my sleep
Like a definition of love.
Saying, this is the moment.
Here, now.

—Ruth Stone, 1971

(Continued on other side)
VERMONT DIVISION FOR HISTORIC PRESERVATION - 2017

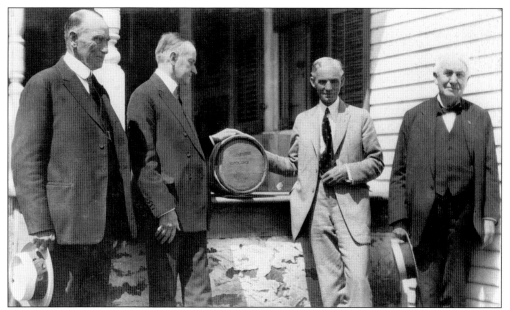

One of only two Vermonters to become president of the United States, Calvin Coolidge presented Henry Ford with a maple syrup bucket at his father's farm, which hosts a marker in his honor. Born in Plymouth, Vermont, Coolidge's political life was rooted in Massachusetts. On a fateful visit to Vermont in 1923, Coolidge learned he had become president. His father—a notary public—administered the oath of office.

Artist Brendon Palmer-Angell created *Reach for the Stars: the Michael Anderson Mural* in downtown Plattsburgh to honor the man who was born on and served at Plattsburgh Air Force Base. The 2021 unveiling ceremony included a performance by the Plattsburgh State Gospel Choir, shown here with Plattsburgh mayor Chris Rosenquest (far left) and Anderson's wife and daughters (middle). (Courtesy of the Plattsburgh State Gospel Choir.)

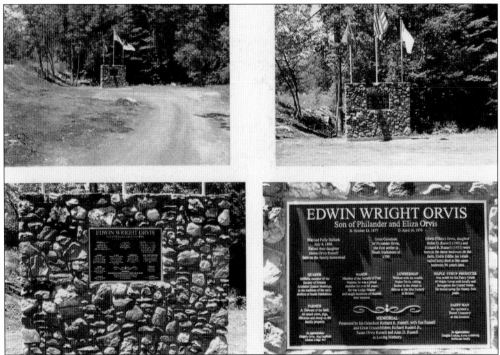

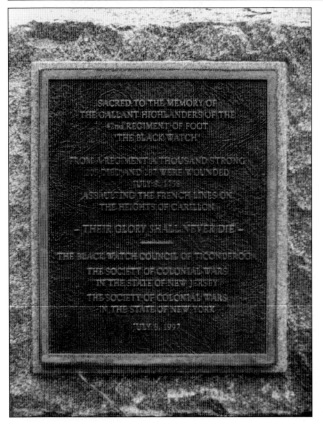

Descendants of Edwin Wright Orvis, himself descended from one of the first settlers of the town, presented this memorial park installation to the town of Bristol, Vermont, in 2018. Built of stone, the monument recounts the life of a man who, in his 96 years, was a Quaker, a Mason, a lumberman, a maple syrup produce, a farmer, and a dairyman. (Courtesy of the Bristol Historical Society.)

Scottish heritage is celebrated in Ticonderoga, New York, with this monument to the Highlanders of the 42nd (Royal Highland) Regiment of Foot, "the Black Watch." More than 200 of the "gallant highlanders" perished and almost 300 were wounded while fighting the French near the Carillon. This monument was erected in 1977.

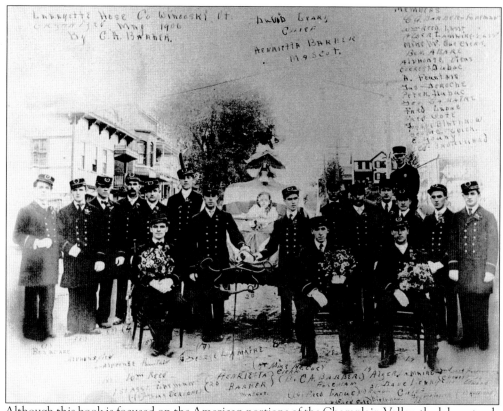

Although this book is focused on the American portions of the Champlain Valley, the lake extends into Québec, and people on both sides of the border share a common culture and many family ties. In fact, descendants of French Canadians are among the most numerous residents of the New York and Vermont portions of the valley and, after decades of being considered "less than" now celebrate their heritage with the preservation of photographs (like the one above, showing Winooski's Lafayette Hose Company), the creation of monuments, and the celebration of festivals, like Winooski's French Heritage Festival, shown below in 2022.

For more than 50 years, the North County Chamber of Commerce has named a deserving citizen Irishman of the Year at its annual St. Patrick's Day breakfast. In 2018, Celine Racine Paquette, who served as a Clinton County legislator from 1996 to 2007 and was the vice chair of the Hudson-Fulton-Champlain Quadricentennial Commission, received the honor in recognition of her character and deeds. (Photograph by Kelli Catana, courtesy of the *Plattsburgh Press-Republican*.)

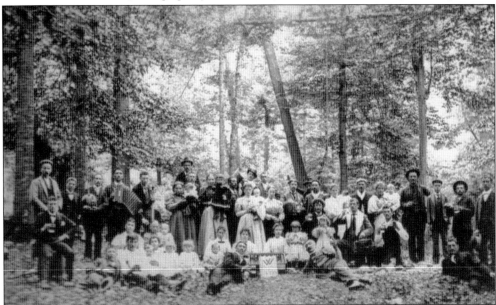

Beginning in the 1880s and 1890s, many Italians emigrated to America to escape uncertainties at home. Those who came to Vermont often settled in Rutland and Barre, where they could work as skilled stone workers and carvers. This photograph shows a group of those workers and their families. Their lives are remembered by several historical markers, including one in Burlington's Little Italy, and by the Vermont Granite Museum.

Two

A WORKING LIFE

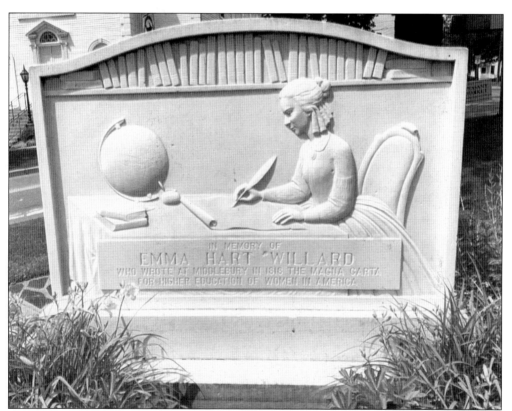

In Middlebury, this monument to Emma Willard bears witness to the educator and activist's work as principal of the local female academy and founder of the Middlebury Female Seminary, where she taught her students subjects like math and philosophy. Willard later moved to New York and opened a school there, becoming known for her educational philosophies. She was named to the National Women's Hall of Fame in 2013.

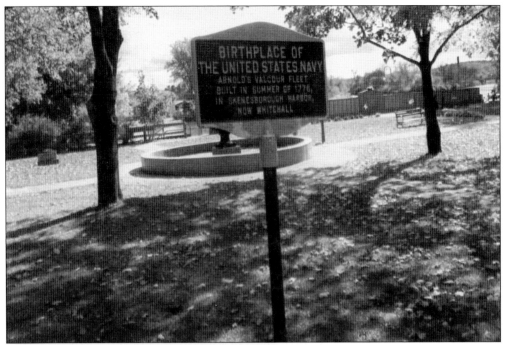

Pivotal battles in both the American Revolution and the War of 1812 were fought on the lake. In 1960, the New York state legislature declared Whitehall the birthplace of the US Navy, recollecting its role in the development of Benedict Arnold's fleet and the later production of ships for the War of 1812.

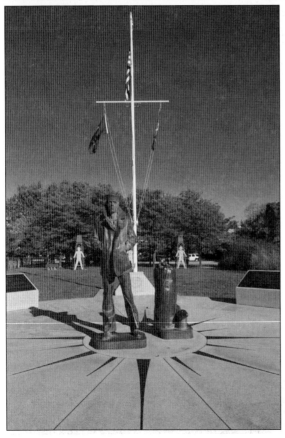

Lone Sailor looks over the waters of Lake Champlain from Burlington's downtown waterfront. Dedicated in 2005, Stanley Bleifeld's statue honors the lake's naval history and those who serve or have served at sea. Commemorative plaques surround the sailor, who stands at the center of a compass. (Photograph in Carol M. Highsmith's America Project in the Carol M. Highsmith Archive, Prints and Photographs Division, Library of Congress.)

Across the lake, the bell of the USS *Lake Champlain*, as well as commemorative panels with the history of the ship and its crew, sits near the Plattsburgh Boat Basin. Commissioned in 1945 and financed by war bonds purchased by the people of New York state, the *Champlain* had a storied history. It was decommissioned in 1966.

Although the original ship was decommissioned, another USS *Lake Champlain* was built. In 2003, five crewmembers from the ship—CPO Gerald Fountaine, PO1 Freddie Shanks, PO2 Mario Orellana, PO2 Patrick Morton, and Sn. Robert Rose—participated in the Battle of Plattsburgh Parade. Fountaine said, "There is no other ship in San Diego that has built such strong ties with a community." (Courtesy of the Clinton County Historian's Office.)

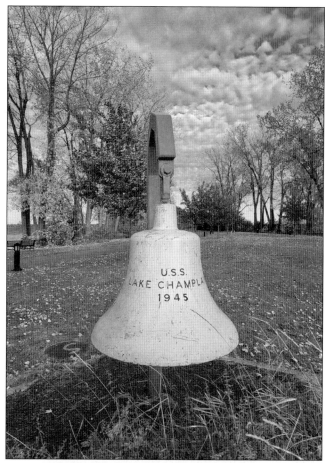

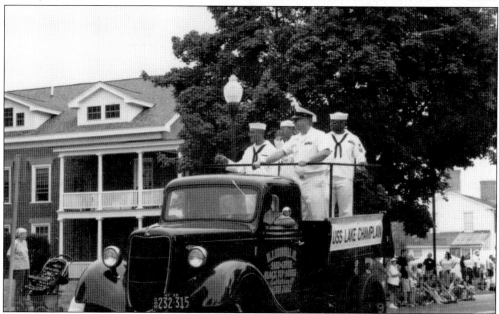

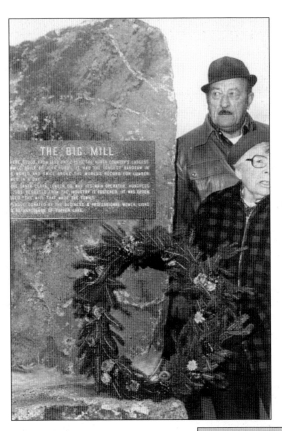

In the 19th century, lumberman John Hurd constructed a mill on this site. Inside the mill, Hurd had the longest bandsaw in the world, with which he twice broke the world record for lumber sawn in one day. Here, Pete Ladue and Dr. Hyla Watters are shown next to the wreath laid at the dedication of the marker in 1970. (Courtesy of the Goff Memorial Library.)

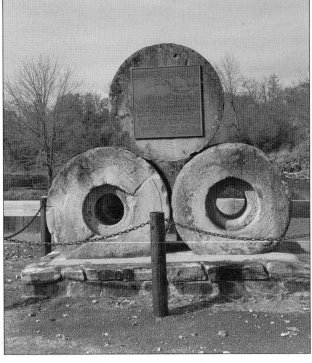

The Saranac River, in Schuyler Falls, New York, was the home of three pulp mills built in 1880 and 1891. In operation until 1927, the mills were then converted to hydroelectric power plants that became the sites of three New York State Electric & Gas power plants. These pieces of the original mills bear witness to the site's industrial past.

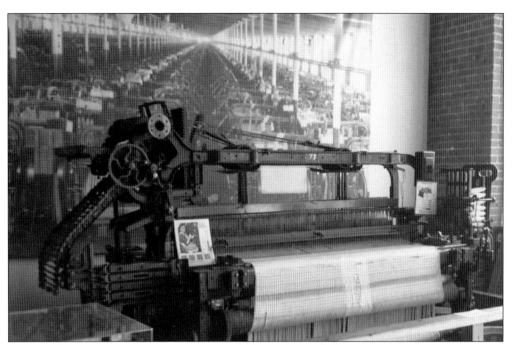

The Champlain Mill stands in the heart of Winooski, Vermont, a monument to the city's industrial past. Familiar even to those who have never been to Vermont because of Lewis Hine's photographs of mill workers, this place is pivotal to the history of the region, a history shared by the Mill Museum and the Winooski Historical Society, both located on the building's main floor.

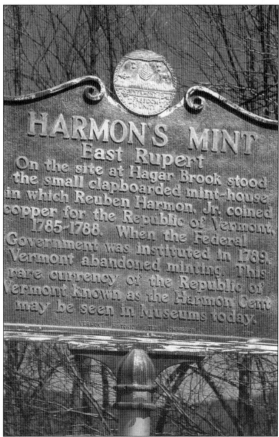

Reuben Harmon Jr. opened Vermont's only official mint, running it from 1785 to 1766. Located in Rupert, the mint produced two copper coin designs for the Republic of Vermont. Known as the "Harmon Cent," the coins are incredibly rare. Metallurgic analysis of the beams indicate that metals were smelted in the building we now know as Harmon's Mint.

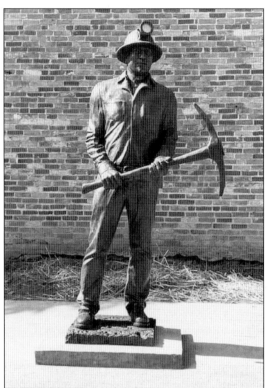

In October 2022, the Town of Moriah dedicated its *Miner Statue*. Created in bronze by artist Joe Lupiani, who was born in Moriah, the statue honors the history of the thousands of local miners who worked in the shafts. The iron ore miner shown here carries a pickaxe and wears a metal mining helmet with a headlamp.

The mining industry was important throughout the Champlain Valley, with major operations in both New York and Vermont. Photographs like this one, of a Clinton County operation, are among the many artifacts held by the Lyon Mountain Mining and Railroad Museum and the Iron Center Museum in Port Henry-Moriah. (Courtesy of the Clinton County Historian's Office.)

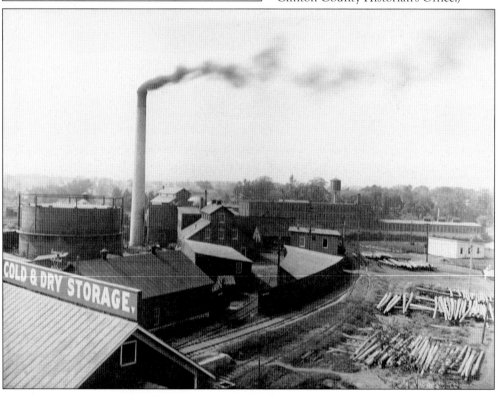

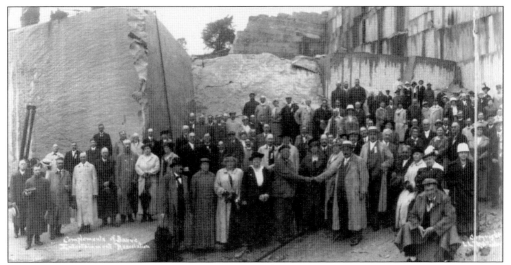

The Association of American Cemetery Superintendents visited Barre, Vermont, "the Granite Center of the World," for its 31st annual convention in August 1917. Founded in 1887, the organization's goal was to improve the appearance and operations of cemeteries. Vermont's stone cutters and carvers were known for their mastery of the medium, producing beautiful headstones and monuments. (Photograph by Lous L. McAllister, courtesy of the Library of Congress.)

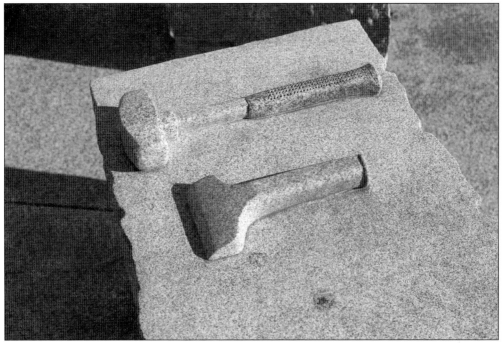

Granite has been an important industry in Vermont since the early 19th century. That history is told by the Vermont Granite Museum and at the Rock of Ages Museum and by sculptures like this one of the tools of the trade. Spread throughout Rutland, the sculptures offer evidence of an ongoing love affair with granite and stone cutting. (Photograph in Carol M. Highsmith's America Project in the Carol M. Highsmith Archive, Prints and Photographs Division, Library of Congress.)

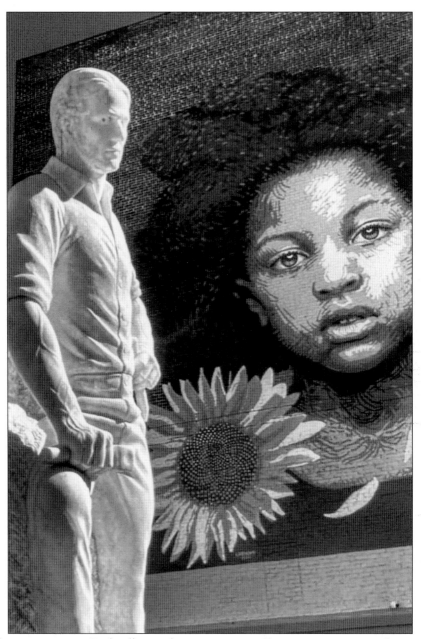

From this vantage point, Rutland's outside art movement offers a stunning vision of past, present, and future. Alessandro Lombardo and Andrea Ingrassi's *Stone Legacy*, the first statue erected as part of the project, is an homage to the Vermonters who established the marble industry in the state. Offering a striking contrast to the white marble sculpture of a life-sized stone carver with a hammer and chisel is LMNOPI's mural *We Who Believe in Freedom Cannot Rest Until it Comes*. With its larger-than-life central figure—a young black woman—and sunflower, the mural offers a vision of what life can be when Vermonters are inclusive. The Rutland Sculpture trail, funded by local philanthropists and crowdfunding campaigns, currently includes eight marble sculptures that feature important historical moments, with more than 20 murals lining the streets of the downtown area as well.

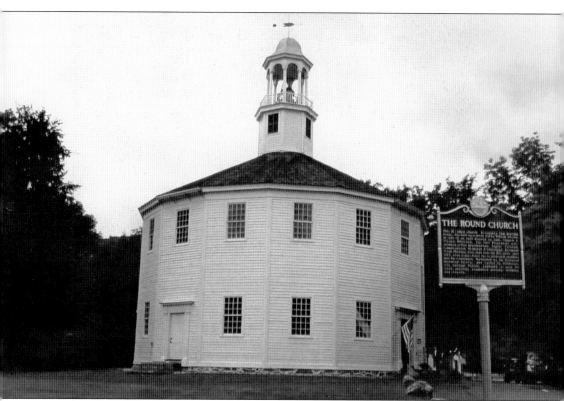

Richmond's Old Round Church is a Vermont icon. Built in 1812–1814 under the direction of local craftsman William Rhodes, the 16-sided meetinghouse was used as a place of worship for the town's five Protestant congregations, each of which advanced money to finance the construction. In 1880, after the founding churches moved out, ownership reverted to the Town of Richmond, which used it as a meeting hall until 1973, when the building's disrepair raised safety concerns. Extensive renovations—including the restoration of the belfry—were undertaken throughout the 1970s and early 1980s after the Richmond Historical Society (RHS) began a 40-year lease of the property in 1976. Reopened to the public in 1981, the structure was designated a national historic landmark in 1996. Now on its second 40-year lease, the church is used for weddings, concerts, and exhibits. As the RHS explains, "The Old Round Church remains a wonderfully well-preserved example of an early New England meeting house."

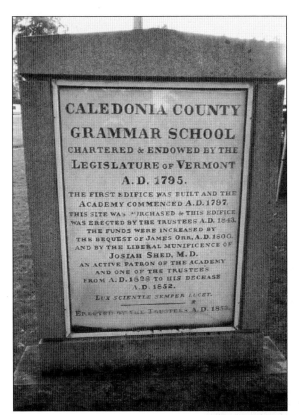

In Vermont, the Caledonia County Grammar School is marked by granite markers that show its location. Engraved with images of the school, each portion of the marker offers a different perspective of the building, which was opened in 1797 and received endowments from various local patrons.

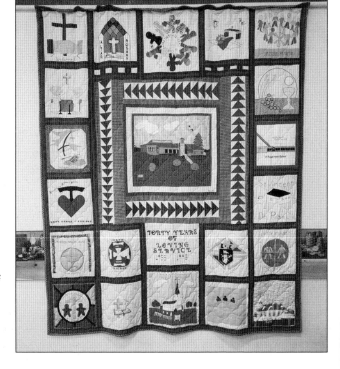

While textiles are often left out of the list of markers and monuments, this quilt demonstrates how beautifully the story of the past can be told via fabric. Created by members of the St. Augustine's Parish in Peru, New York, upon the occasion of their pastor's retirement, each square offers a different facet of the priest's history.

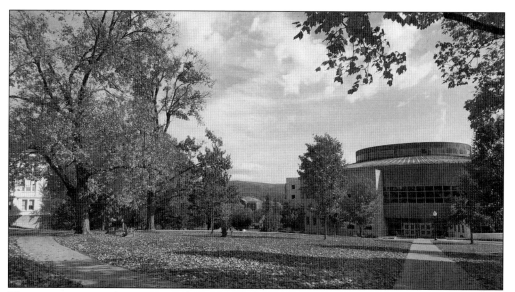

The permanent settlement of Middlebury, Vermont, began in 1783, and Middlebury College opened 17 years later on land donated by local lawyer Seth Storrs. Since that time, town and gown have coexisted happily, particularly since the college's founders declared that Middlebury was "the town's college," a reality commemorated by one of many markers in Middlebury, whose mingling of campus and community may be seen in this photograph. (Courtesy of Rania al-Bahara.)

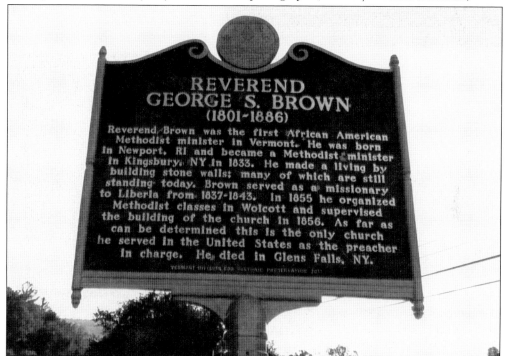

During the 1850s, Rev. George S. Brown led the Methodist congregation of Wolcott, Vermont, and oversaw the construction of their church. On the face of it, that is hardly a remarkable history. However, Brown was the first African American Methodist minister in Vermont, a fact made all the more remarkable by the location of his parish in one of the least diverse parts of the state.

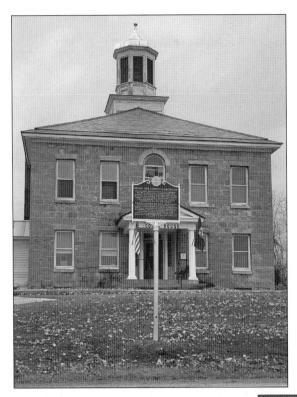

The Grand Isle County Courthouse in North Hero, Vermont, was built in 1824 of locally-quarried limestone. With its belfry rising from the center of the hipped roof and its gabled portico surrounding the entrance, the structure became a model for Vermont's civil architecture. After 1865, when the town hall and church were moved to another site, the building's sole use reverted to that of a courthouse and jail.

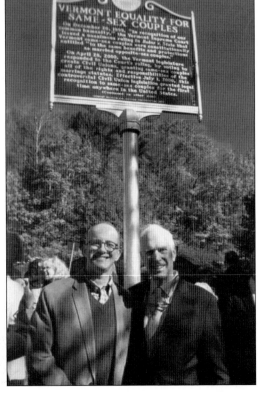

In 2009, Vermont enacted legislation allowing same-sex marriage, the first state to do so. Rather than relying on court rulings to offer marriage equality to its citizens, the Vermont legislature chose to use its voice to create a new law, and in doing so, offered same-sex couples throughout the United States an avenue to marry legally.

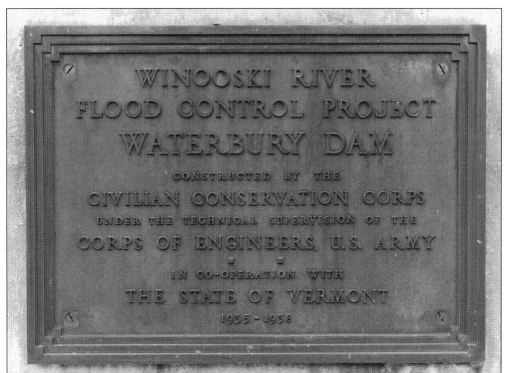

The flood of 1927, which caused about $13 million in damage and killed more than 55 people, necessitated the Waterbury Dam. Built over three years (1935–1938) by World War I veterans brought in by the US Army Corps of Engineers, the 190-foot earthen dam is considered an amazing feat of engineering and technology for its time. The 2,000 men who built this dam and others in the area lived at its base while doing the work.

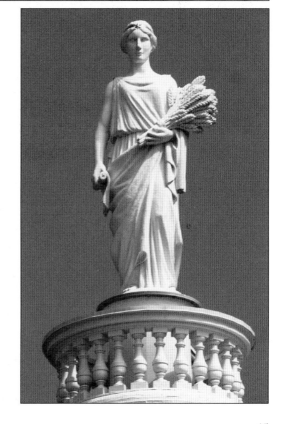

High atop the Vermont State House dome, *Agriculture* has an interesting history of its own. The original statue was carved in pine by Brattleboro artist Larkin Mead and put in place in 1858. When that version rotted, it was replaced by a new statue, carved by Dwight Dwinell. The latest iteration, shown here and based on the original, was created by Vermont sculptors Jerry Williams and Chris Miller.

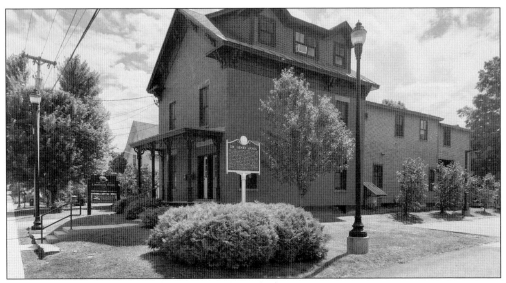

Born in Waterbury, Vermont, Dr. Henry Janes brought his vast experience as a surgeon, house doctor, and general practitioner with him to the battlefields of the Civil War, serving with the 3rd Vermont Volunteers (1861–1863) and the US Volunteers (1863–1866). Upon returning home, he continued his local practice, consulting with the Mary Fletcher Hospital in Burlington and the Heaton Hospital in Montpelier.

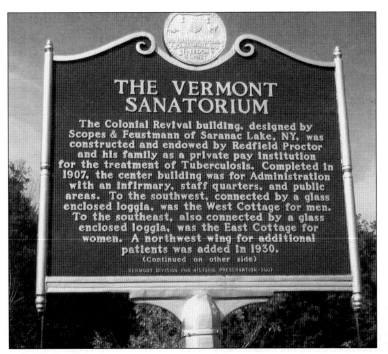

The mountain air of the Green Mountains and Adirondacks was believed to be the best way to treat tuberculosis in the early part of the 20th century. In 1907, the firm of Scopes and Feustmann designed the Vermont Sanatorium for Redfield Proctor, whose family was determined to use part of their fortune to help defray the cost of treatment for patients of moderate means. In 1921, the institution was donated to the state.

For years, the name Waterbury was synonymous with "asylum" because of the placement of the Vermont State Hospital in the town. Built in 1890, the facility treated patients with a variety of mental health issues. Sadly, patients with other issues—like epilepsy, alcoholism, and senility—were also seen as insane during the early days of the hospital. This is now the site of state offices.

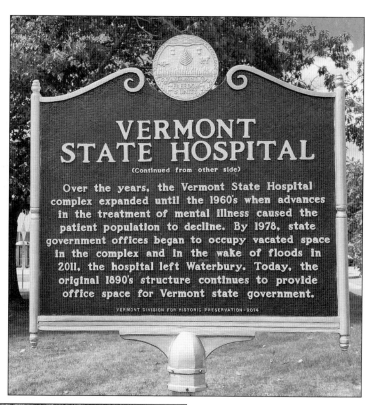

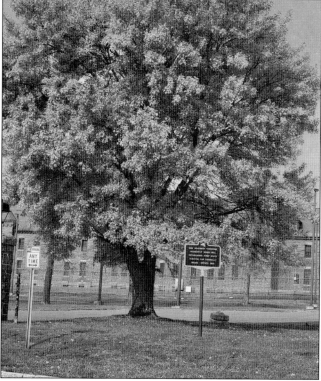

Across the lake, Dannemora is the site of the first State Hospital for the Criminally Insane. The facility, which opened in 1900, housed convicts who became insane after imprisonment and also those deemed criminally insane. An immense stone building, seen here behind the tree and security fence, the hospital is now part of the Clinton Correctional Facility.

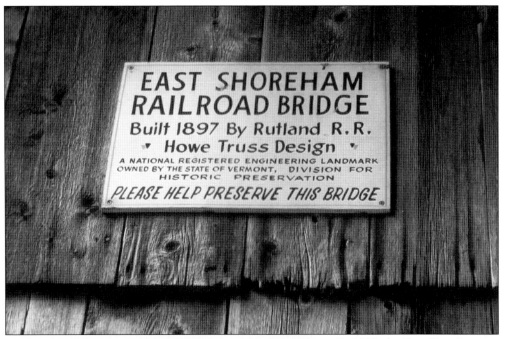

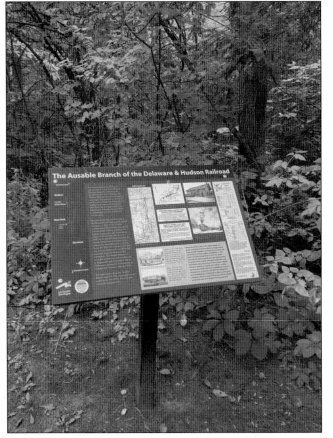

By 2013, the East Shoreham Railroad Bridge was one of only two covered railroad bridges left in Vermont. Built in 1897, the bridge used the Howe truss design and was a National Registered Engineering Landmark, as indicated by this sign inside the bridge. Another marker erected by the Vermont Division for Historic Preservation is outside the structure.

Nestled in the Town of Peru, New York, Heyworth Mason Park celebrates local industrial and natural history. In addition to wayside markers that describe the local flora and fauna and historical paintings that have been added to the Heyworth building, the park offers the history of the Ausable branch of the Delaware & Hudson Railroad, which ran from Plattsburgh southwest to the Clintonville–Ausable Forks area.

For more than 150 years, the independent Delaware & Hudson Railroad connected New York to Quebec and New England. With depots along the lake, the railroad opened northern New York to tourism, offering travelers lodging like the company's Hotel Champlain, located between Peru and Plattsburgh. The Rouses Point station, built in 1889, was restored and now houses a local history museum.

SITE OF
DELAWARE AND HUDSON
RAILROAD STATION
BUILT IN 1889
NATIONAL HISTORIC REGISTER
FEBRUARY - 2005

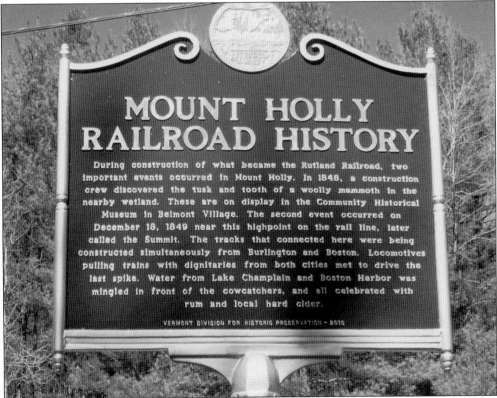

MOUNT HOLLY RAILROAD HISTORY

During construction of what became the Rutland Railroad, two important events occurred in Mount Holly. In 1848, a construction crew discovered the tusk and tooth of a woolly mammoth in the nearby wetland. These are on display in the Community Historical Museum in Belmont Village. The second event occurred on December 18, 1849 near this highpoint on the rail line, later called the Summit. The tracks that connected here were being constructed simultaneously from Burlington and Boston. Locomotives pulling trains with dignitaries from both cities met to drive the last spike. Water from Lake Champlain and Boston Harbor was mingled in front of the cowcatchers, and all celebrated with rum and local hard cider.

VERMONT DIVISION FOR HISTORIC PRESERVATION - 2015

Operating principally in the state of Vermont but extending into New York at the north and south of Lake Champlain, the Rutland Railroad began operation in the 19th century and closed in 1961. Significant in its own right, the construction of the railroad also gave rise to a significant find when workers were building a line in Mount Holly and discovered a woolly mammoth tusk and tooth.

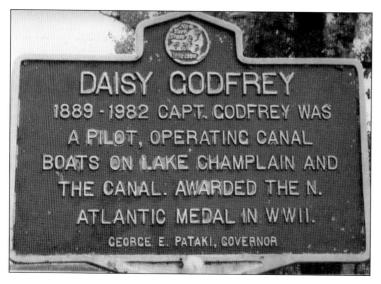

A canal boat pilot operating in the Champlain Valley, Daisy Godfrey was honored by this marker in honor of her long local history and as a winner of the North Atlantic Medal in World War II in 1998. Of her seagoing life, Godfrey explained that she had been on the water since her first trip on her father's schooner before she was a year old.

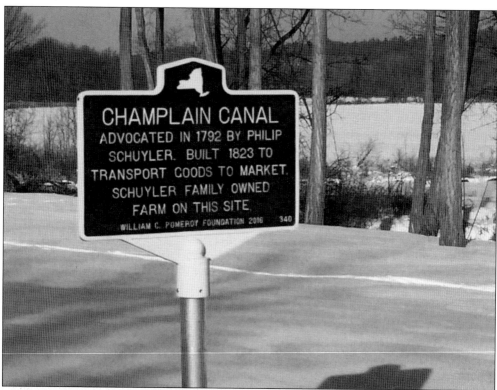

The Champlain Canal, built in 1823, extended the centuries-long history of the route north to Canada and south to the Atlantic Ocean. Whereas travelers once had to carry their boats and cargo over the lowlands between Lake Champlain and the Hudson River, the canal offered an all-water passage, changing the landscape of the region and bolstering the ship- and canal boat–building industries on both sides of the lake.

Water travel was extremely important to early settlers of the region. From Champlain's first voyages aboard the canoes of indigenous peoples, the waterways served as a means to find the resources necessary for life. In 1808, Matthew Sax built a steamboat wharf, using newer technology, to connect Whitehall, New York, and St. Johns, Quebec.

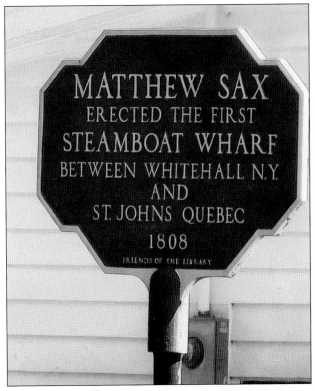

Although Ausable Falls, New York, is best known as a tourist destination, the falls also provided an economic lifeline. In 1876, Rainbow Falls proved a practical location for a hydroelectric mill that powered a paper mill, a door and window-sash factory, and a starch mill. This wayside marker, erected by New York State Electric & Gas, recounts that history for visitors to the area.

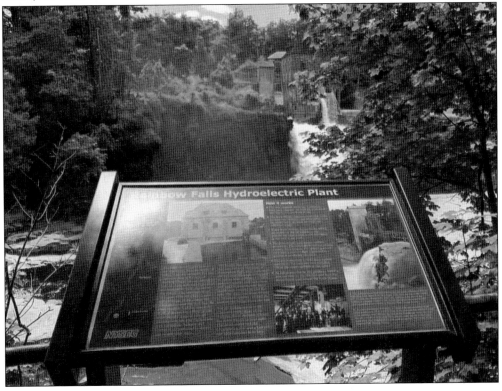

Some stories, like that of the auto ferry that operated between Chazy, New York, and Isle la Motte, Vermont, are so significant to local history that they are commemorated on both sides of the lake. Will Sweet designed, built, owned, and operated the first gas-powered ferry on Lake Champlain. Named the *Twins* in honor of his twin sons, the ferry allowed a continuous automobile route across the lake in the days before the Rouses Point–Alburg Bridge was built. A larger ferry, the *Twin Boys*, was built later and operated until 1937. In 2008, Chazy historian Bob Cheeseman helped to unveil the New York state historic marker; the same year, a marker was also unveiled in Vermont.

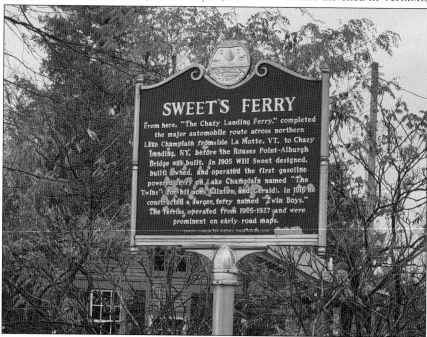

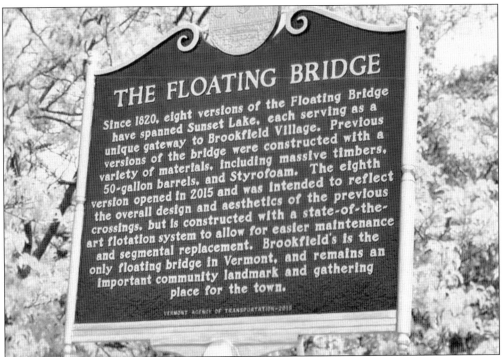

THE FLOATING BRIDGE

Since 1820, eight versions of the Floating Bridge have spanned Sunset Lake, each serving as a unique gateway to Brookfield Village. Previous versions of the bridge were constructed with a variety of materials, including massive timbers, 50-gallon barrels, and Styrofoam. The eighth version opened in 2015 and was intended to reflect the overall design and aesthetics of the previous crossings, but is constructed with a state-of-the-art flotation system to allow for easier maintenance and segmental replacement. Brookfield's is the only floating bridge in Vermont, and remains an important community landmark and gathering place for the town.

VERMONT AGENCY OF TRANSPORTATION-2015

For many, Vermont is most known for its covered bridges. Yet a variety of bridges traverse the state's multitude of rivers, streams, and creeks. Two of the most important are the Floating Bridge in Brookfield and the Lenticular Truss Bridge in Highgate. Buoyed by pontoons, the Floating Bridge (marker shown above) was first built in 1820 by Luther Adams. The Lenticular Truss Bridge (below) was built by the Berlin Iron Bridge Company in 1887. The design for the bridge used less metal than conventional truss bridges, allowing it to be made for less money. Both of these bridges have been recognized with markers honoring their unique history and place in Vermont life.

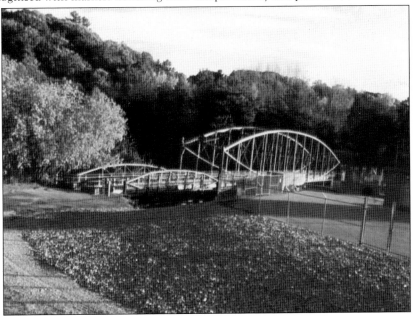

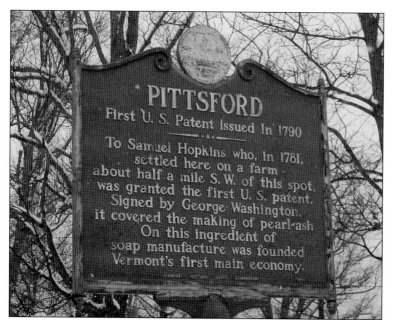

Pittsford, Vermont, erected this monument in honor of the first patent issued in 1790 by George Washington under a newly-approved statute. Unfortunately, they later discovered that the patent was not issued to the local Samuel Hopkins and removed the sign.

Chazy, New York, businessman William H. Miner got his start by patenting a shock-absorbing device for railway cars. With his wife, Alice, he became a major philanthropist, responsible for building the Physicians Hospital, Chazy Central Rural School, the Alice T. Miner Museum, and—through his foundation—the Miner Agriculture Research Institute. Hearts Delight Farm, his homestead, offers an intriguing glimpse of the man behind the legacy.

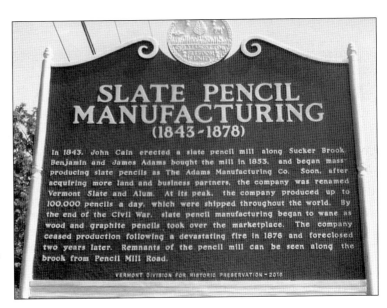

CLARENCE W. FITCH
COMMUNITY ACTIVIST

Clarence W. Fitch, born in 1885 in East Montpelier, was a leader of the cooperative movement of the mid-20th century, when rural families banded together to create social and cultural organizations for the benefit of their communities. He founded one of the first credit unions in Vermont on this site in 1936, and served as its treasurer from 1941 to 1965. Fitch served as president of the Granite City Cooperative Creamery, the Washington Electric Cooperative, the Vermont Credit Union, the Vermont Credit Union League, and the Adamant Cooperative Store.

Scientific farmer, postmaster, legislator, and educator, Clarence Fitch deeply touched and enhanced the lives of his local and regional community. He died in 1968 in Calais.

Admirably, the State of Vermont's Division for Historic Preservation has made a concerted effort to recognize histories that might otherwise be lost. This marker remembering Clarence W. Fitch, leader of the cooperative movement, community activist, lawmaker, and educator, is one such nod to the past. Although Fitch "deeply touched and enhanced the lives of his local and regional community," his history is not easy to uncover.

One of Castleton, Vermont's, claims to fame is that, in the 1800s, after he realized that slate could be used as a writing tool, John Cain established a factory to manufacture slate pencils here. In fact, the "Slate Belt" that runs through New York and Vermont offered many options to quarry the material, which was used to make blackboards and tablets as well.

SLATE PENCIL MANUFACTURING
(1843-1878)

In 1843, John Cain erected a slate pencil mill along Sucker Brook. Benjamin and James Adams bought the mill in 1853, and began mass producing slate pencils as The Adams Manufacturing Co. Soon after acquiring more land and business partners, the company was renamed Vermont Slate and Alum. At its peak, the company produced up to 100,000 pencils a day, which were shipped throughout the world. By the end of the Civil War, slate pencil manufacturing began to wane as wood and graphite pencils took over the marketplace. The company ceased production following a devastating fire in 1876 and foreclosed two years later. Remnants of the pencil mill can be seen along the brook from Pencil Mill Road.

VERMONT DIVISION FOR HISTORIC PRESERVATION - 2016

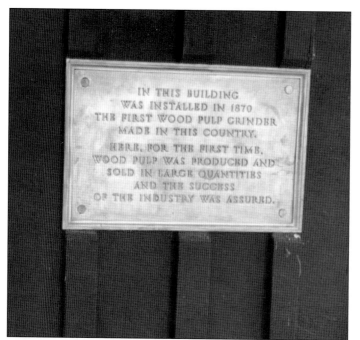

The first American-made wood pulp grinder was installed in Lake Luzerne, New York, in 1868. Allowing for the creation of paper from wood—a readily available commodity in the Champlain Valley—this export changed life in the region, which has gone on to include the manufacturing of paper products. During celebrations of Lake Luzerne's 225th anniversary, this history was commemorated.

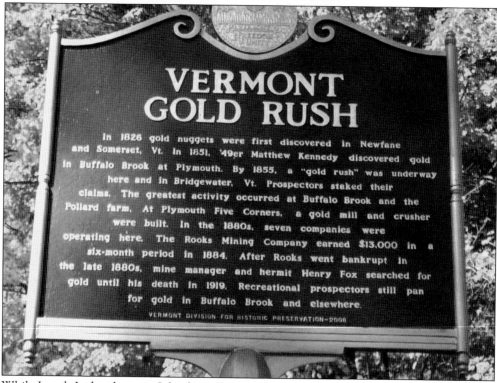

While Joseph Ladue, born in Schuyler Falls, New York, had to travel west to prospect for gold, Vermonters prospected locally after finding nuggets in Somerset. As reported by the state geologist in 1845, the discovery of gold was downplayed, though prospectors continued panning for gold in Buffalo Creek and surrounding areas.

Three

THE CULTURAL LANDSCAPE

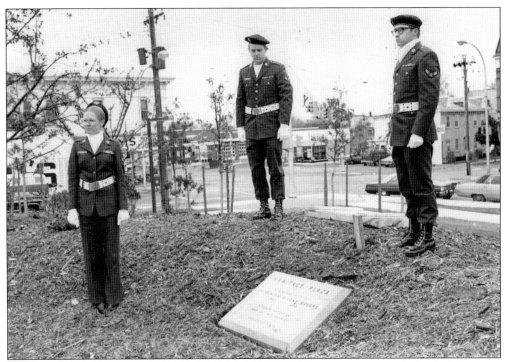

The Clinton County Government Center, designed by the firm of Jeremiah Oosterbahn, was dedicated in 1976, soon after construction of the Old Court House was completed. Local military personnel participated in the ceremony, and the newly designed Heritage Plaza was created in memory of Benjamin Mooers, a veteran of both the Revolutionary War and the War of 1812 and an early settler of the county. (Courtesy of the Clinton County Historian's Office.)

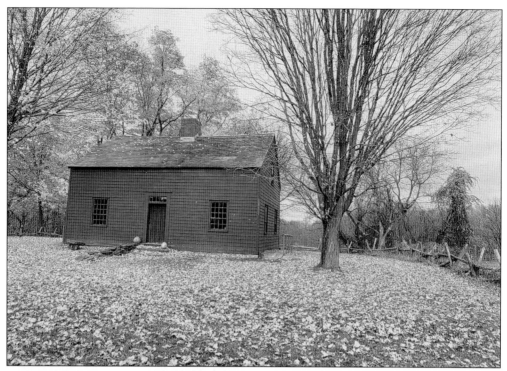

70468 SPLIT ROCK ROAD, ETHAN ALLEN PARK, BURLINGTON, VT.

Farmer and folk legend Ethan Allen is most remembered for his role as a leader of the Green Mountain Boys. His homestead, built in 1787 soon after the Allen family moved to Burlington, was restored in the 1980s. Now the Ethan Allen Homestead Museum, the building offers a vision of 18th-century life. A recent partnership with the Alnôbaiwi hopes to bring an indigenous heritage center to the site.

Near the north end of Burlington, Ethan Allen Park opened in the early part of the 20th century. Visitors to "the Pinnacle," where William Van Patten placed a gazebo, were interested in the local wildlife, birds, trees, and wildflowers. The park's 67 acres include trails, a playground, picnic areas, and the tower (opposite). In 1937, a Works Progress Administration crew widened the entrance to the park.

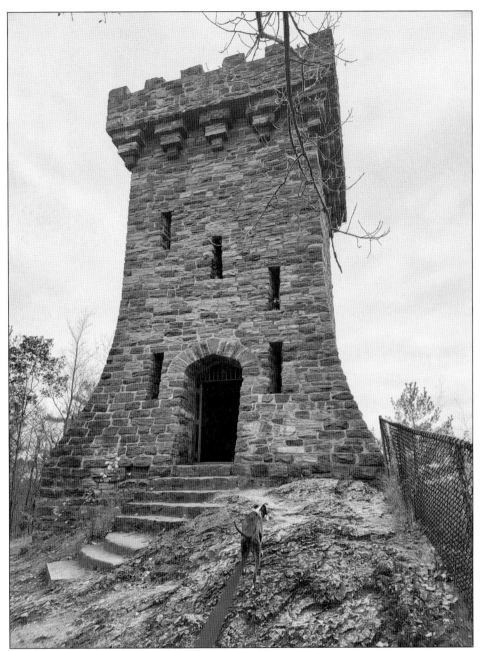

The 40-foot-tall Ethan Allen Memorial Monument was conceived by William Van Patten and the Sons of the American Revolution (SAR) in 1902. Wishing for a chance to memorialize the property's first owner who they referred to as "the founder of the state of Vermont and the Establishment of American independence," Van Patten deeded 15 acres of land to the SAR, which in turn raised the money necessary to build the tower. In 1905, the tower, made of dolostone quarried nearby, officially opened. It was such a source of pride to local citizens that, for the first time, they approved the appropriation of another $10,000 by the city government to buy the remainder of the current park. While the tower and park are named in honor of Allen, the Abenaki used this bluff, with its remarkable vista, for centuries to watch for Iroquois and Mohawk boats on the lake.

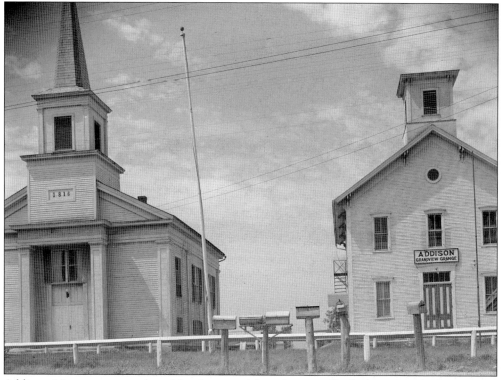

Addison, Vermont, remembered her heroes with an honor roll of service attached to a stone pedestal in 1922. Created by the Patriotic League of Addison and the Rhoda Ferrand Chapter of the Daughters of the American Revolution, the marker—later joined by another honor roll for later conflicts—is in front of the church and grange.

Chartered in 1763, the town of Colchester, Vermont, celebrates its history with an approximation of a village green. With the Meeting House (shown here) at one end, the brick Burnham Memorial Library next door, and the United Church of Colchester at the southeastern end, the area harkens back to an earlier time. The Colchester Village Cemetery is behind the buildings.

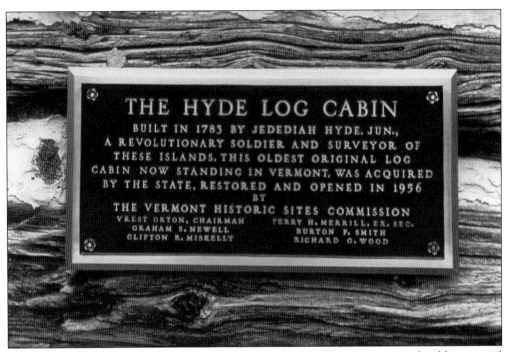

Built by Jedediah Hyde Jr. in 1783, the Hyde Log Cabin in Grand Isle, Vermont, is the oldest original log cabin still standing in the state. After it was moved to this site in 1946, Vermont acquired the property, restored it, and opened it to the public in 1956. Now managed by the Grand Isle Historical Society, the cabin is used as a museum. (Photograph in Carol M. Highsmith's America Project in the Carol M. Highsmith Archive, Prints and Photographs Division, Library of Congress.)

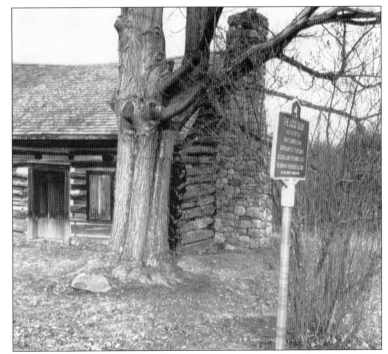

Another of the oldest log structures in the country is in Willsboro, New York. Constructed more than 200 years ago, the Adsit Log Cabin was built by American Revolution veteran Samuel Adsit, who could hear the noise of the Battles of Plattsburgh and Lake Champlain from the site. Owned by the Town of Willsboro, the site is operated by the Adsit Cabin Committee of the Willsboro Heritage Society.

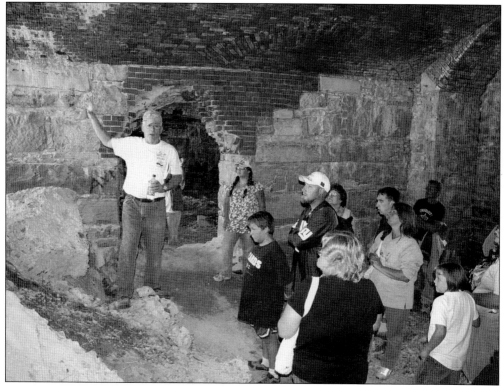

Fort Montgomery lies just north of the Rouses Point–Alburg bridge. Named for Gen. Richard Montgomery, a Revolutionary War hero, the fort was sold at auction in 1926. Here, Jim Millard, a local historian and expert on the site, leads a tour of the structure, named one of the "Seven to Save" most endangered sites in the state in 2009. (Photograph by Bruce Rowland, courtesy of the *Plattsburgh Press-Republican*.)

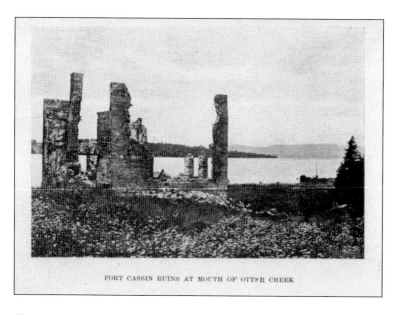

FORT CASSIN RUINS AT MOUTH OF OTTER CREEK

During the War of 1812, Fort Cassin was established near Vergennes, Vermont, to defend the Macdonough shipyard, where the 140-foot-long *Saratoga* was under construction. Named for naval lieutenant Stephen Cassin, who commanded the armed schooner *Ticonderoga*, the fort was abandoned at the end of the war.

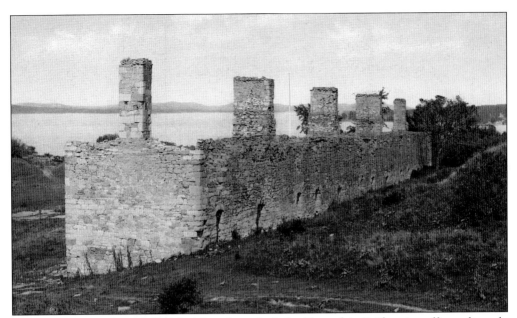

Situated at the southern end of the lake, where the Lake Champlain Bridge now offers a through-route between New York and Vermont, the Crown Point Historic Site recalls the history of Fort St. Frederic and the British Fort of Crown Point. The ruins, which date from the early 18th century, were acquired by the State of New York in 1910. (Courtesy of the Library of Congress.)

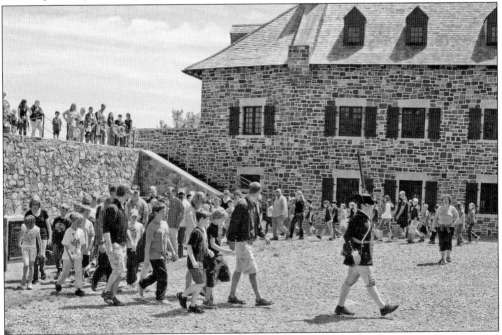

Fort Ticonderoga was controlled by the French, British, and Americans at different points. Falling into ruin after being abandoned at the end of the American Revolution, the site was opened as a historic site in 1909, designated a national historic landmark in 1960, and listed in the National Register of Historic Places in 1966. (Photograph by Lohr McKinstry, courtesy of the *Plattsburgh Press-Republican*.)

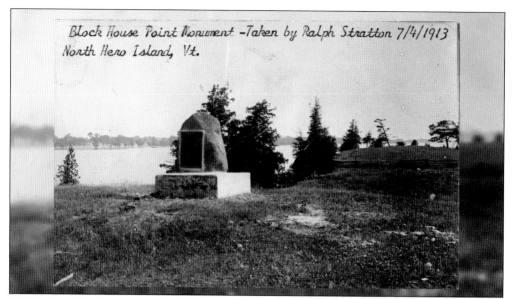

Smaller fortifications were placed along the lake to provide observation points. This marker, photographed by Ralph Stratton in 1913, recalls the British blockhouse on North Hero Point, Vermont. Justus Sherwood, originally a Green Mountain Boy but later a Loyalist, operated at least some of the time from this location, gathering intelligence for the British.

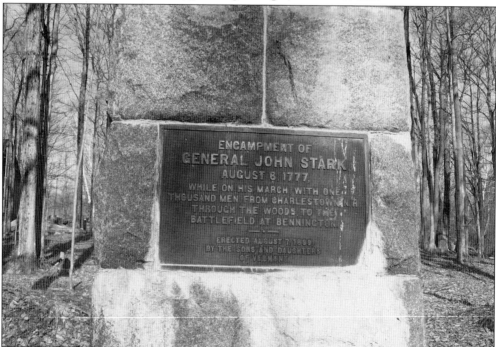

At the southwesternmost part of the Champlain Valley, Peru, Vermont, remembers Gen. John Stark and his 1777 encampment with this marker. The New Hampshire–born Stark organized a militia after returning from his service in Trenton and Princeton. His troops marched through the town on their way to Walloomsac, New York, where they engaged the British during the Battle of Bennington. (Courtesy of Doug Kerr.)

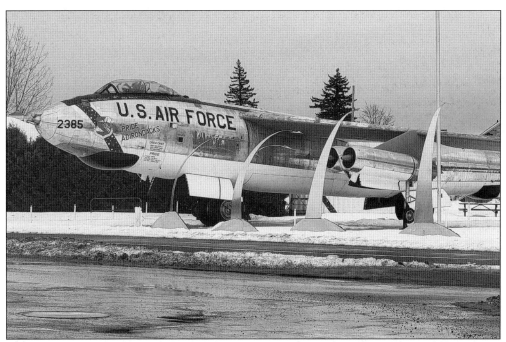

Home to various forts and a US Army barracks, Plattsburgh is best known for its US Air Force base, which opened in 1954 and closed in 1995. A Strategic Air Command facility, the base was home to a variety of aircraft over the years and was a backup landing site for space shuttles. The history of the Air Force's presence in the area can be seen at Clyde Lewis Air Park, with its B-47 bomber and FB-11 fighter jet and historic markers (above), a historic mosaic at the Plattsburgh International Airport (not pictured), and the Plattsburgh Air Force Base Museum, with its collection of objects and artifacts from the base and its personnel (below). Vermont's military heritage has a similar home in the Vermont National Guard Library & Museum and the Fort Ethan Allen Museum.

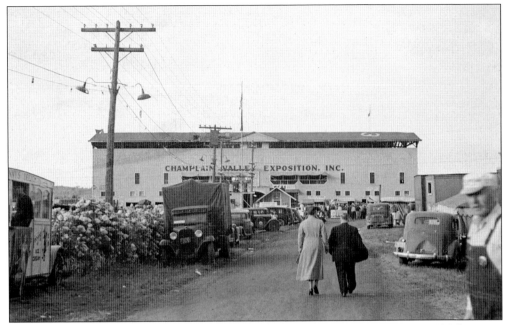

Though not a traditional monument, the Champlain Valley Exposition, now in its 100th year, is an iconic part of Vermont's history and home to the Vermont Agricultural Hall of Fame, which has inducted more than 80 members noted for their emerging leadership, innovation, or lifetime achievements in agriculture. Seen here is the entrance to the fairgrounds in September 1937. (Photograph by Arthur Rothstein, courtesy of the Library of Congress.)

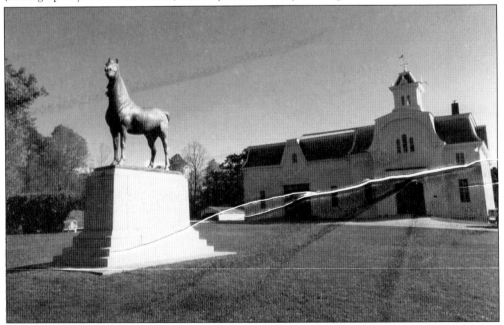

In 2007, the Vermont Division for Historic Preservation recognized the US government Morgan Horse Farm, shown here, for its development of a breeding program to study and refine the Morgan horse for use in the cavalry. That program moved to this site in 1907, and ownership of the farm and continuation of the program was taken over by the University of Vermont in 1951.

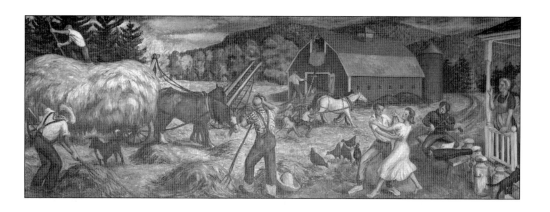

Vermont's agricultural heritage is further commemorated by Philip Von Saltza's murals *Haying* and *Sugaring Off*, both housed in the St. Albans Federal Building. Completed as part of the New Deal's Treasury Section of Fine Arts in 1939, the murals offer a glimpse of two of the state's most important seasons, when hay is cut and stored and when maple trees are tapped, sap gathered, and maple syrup produced. (Both photographs in Carol M. Highsmith's America Project in the Carol M. Highsmith Archive, Prints and Photographs Division, Library of Congress.)

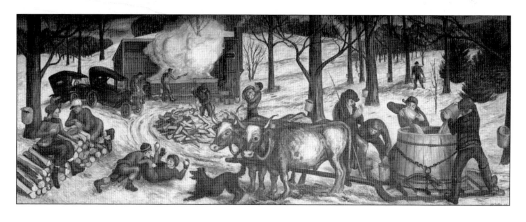

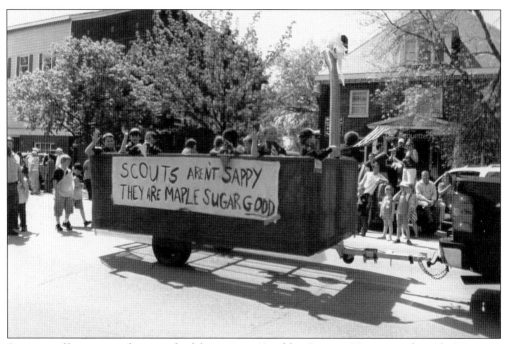

Sugaring off-season sparks annual celebrations in Franklin County, Vermont, where the Vermont Maple Festival offers events for the whole family. Held in April after the busy season is over, the festival includes banquets, art shows, sugarhouse tours, and a parade. In this photograph are Boy Scouts punning their way through a recent parade.

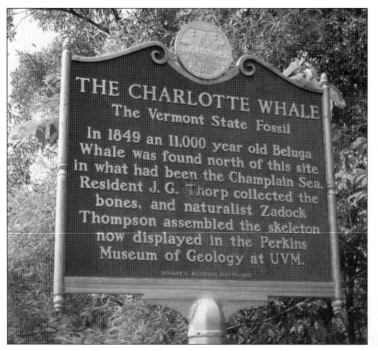

In 1993, the Charlotte whale was declared Vermont's state fossil. Discovered in 1849 when workers were building the railroad between Rutland and Burlington, the beluga whale's bones offer evidence of the Champlain Sea, an arm of the ocean that pushed into the Champlain Valley following the retreat of the glaciers more than 12,000 years ago. While this marker is in Charlotte, the fossil resides at the University of Vermont Perkins Museum of Geology.

Lined with 1,000-foot cliffs, Smugglers' Notch is a narrow pass through the Green Mountains. Reputedly the route for cattle smugglers and bootleggers, the Notch is a popular tourist destination for picnicking families and skiers. Smugglers' Notch State Park, with structures first built by the Civilian Conservation Corps, was relocated in 2003 to allow for a larger campground and newer facilities.

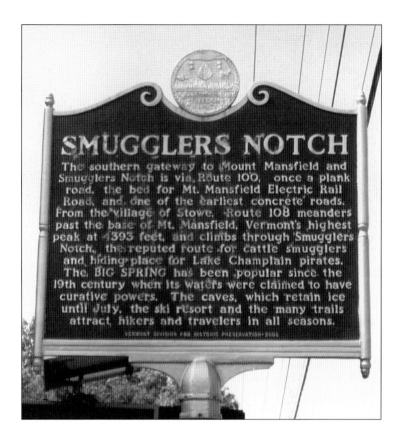

SMUGGLERS NOTCH

The southern gateway to Mount Mansfield and Smugglers Notch is via Route 100, once a plank road, the bed for Mt. Mansfield Electric Rail Road, and one of the earliest concrete roads. From the village of Stowe, Route 108 meanders past the base of Mt. Mansfield, Vermont's highest peak at 4393 feet, and climbs through Smugglers Notch, the reputed route for cattle smugglers and hiding place for Lake Champlain pirates. The BIG SPRING has been popular since the 19th century when its waters were claimed to have curative powers. The caves, which retain ice until July, the ski resort and the many trails attract hikers and travelers in all seasons.

VERMONT DIVISION FOR HISTORIC PRESERVATION-2005

Wilson A. "Snowflake" Bentley was born in Jericho, Vermont, on February 9, 1865. A farmer and self-taught scientist, he focused his work on photomicrography and, in doing so, advanced the field of meteorology. Bentley is most famous for his photographs of snow crystals, which offered the world insight into the shape and design of snowflakes. He is honored by a marker in his hometown.

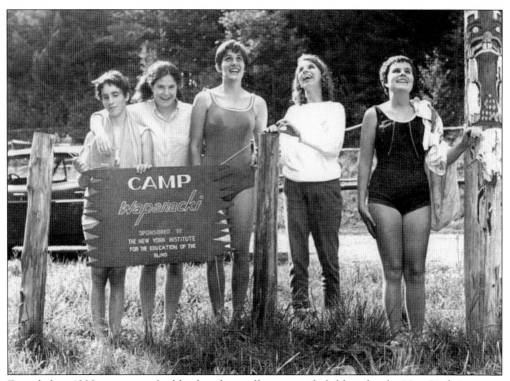

Founded in 1938 as a camp for blind and visually impaired children by the New York Institute for Special Education, Camp Wapanacki was sold to the Girl Scouts of America in the 1980s. Now a four-season camp for adults and families, the camp embraces its unique history and revels in the natural beauty of Vermont's Northeast Kingdom. (Courtesy of the New York Institute for Special Education.)

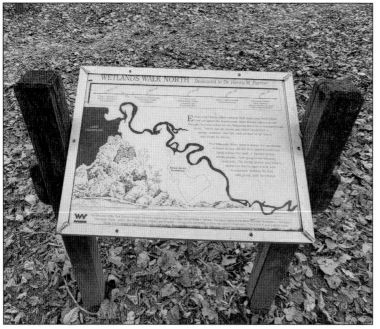

Beyond the commemoration of a Green Mountain Boy, the Ethan Allen Homestead celebrates the landscape with wayside markers like this one dedicated to Henry M. Farmer, a local politician and doctor. Recalling the significance of the Winooski River from 3000 BCE to 1981 CE, the marker provides information for anyone walking a wetlands trail at the homestead.

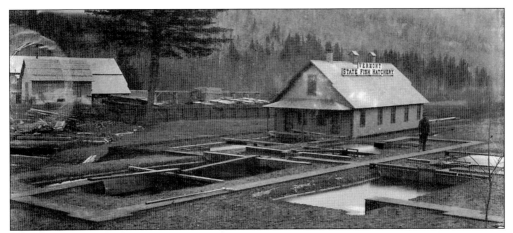

Established in 1891, the Roxbury Fish Culture Station is the oldest in Vermont. With abundant spring water and the nearby Central Vermont Railroad, this site was chosen to address dwindling fish populations in the state. After heavy damage by Tropical Storm Irene, a modern facility replaced the earlier hatchery, ice house, and carriage barn.

In Charlotte, Vermont, this plaque commemorates the Holmes Creek Bridge, designed to be a load of hay high and wide. It also recalls the Holmes family for whom the bridge is named and their apple orchard, believed to be the largest in New England. Apples grow well throughout the Champlain Valley, with Vermont orchards growing more than 150 varieties and their New York counterparts at least as many.

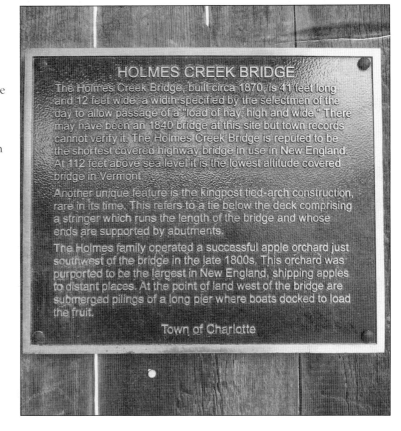

HOLMES CREEK BRIDGE

The Holmes Creek Bridge, built circa 1870, is 41 feet long and 12 feet wide, a width specified by the selectmen of the day to allow passage of a "load of hay, high and wide." There may have been an 1840 bridge at this site but town records cannot verify it. The Holmes Creek Bridge is reputed to be the shortest covered highway bridge in use in New England. At 112 feet above sea level it is the lowest altitude covered bridge in Vermont.

Another unique feature is the kingpost tied-arch construction, rare in its time. This refers to a tie below the deck comprising a stringer which runs the length of the bridge and whose ends are supported by abutments.

The Holmes family operated a successful apple orchard just southwest of the bridge in the late 1800s. This orchard was purported to be the largest in New England, shipping apples to distant places. At the point of land west of the bridge are submerged pilings of a long pier where boats docked to load the fruit.

Town of Charlotte

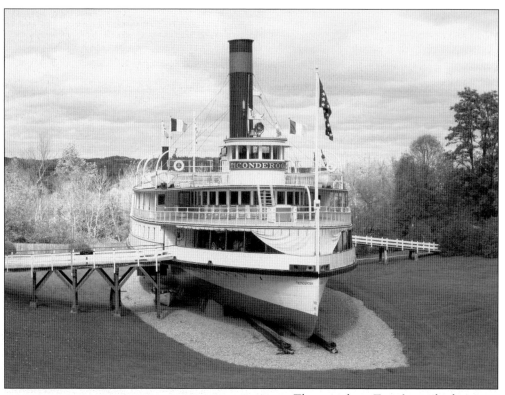

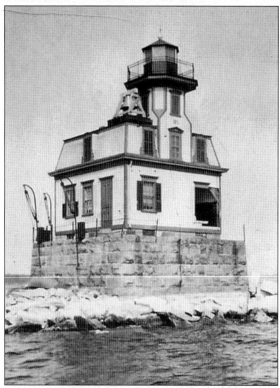

The steamboat *Ticonderoga*, built in 1906 in Shelburne, operated on Lake Champlain as a day boat until 1950. Now considered a national historic landmark (added in 1964), the *Ticonderoga* was moved through an elaborate process of floating the boat over a railroad carriage, removing water from the basin, and bringing the boat by train to the Shelburne Museum campus, where it was restored to demonstrate life aboard in 1923. (Wikimedia/Storylanding.)

Close by, the Colchester Reef Lighthouse watches over the campus of the Shelburne Museum. Originally built in 1871, the lighthouse marked reefs southwest of South Hero and a mile out from Colchester Point. A special wooden crib was sunk and filled with concrete and stone to form a foundation for the lighthouse. After it was abandoned, it was dismantled and reconstructed at the museum in 1952. (Courtesy of the US Coast Guard.)

Discovered by divers in 1986, the anchor of the ship *Confiance* was given to the New York State Museum by the British government two years later. After renovation at the Lake Champlain Maritime Museum in Ferrisburgh, Vermont, the anchor was placed on permanent display at Plattsburgh's city hall where it helps to tell the story of the Battle of Plattsburgh.

Within sight of the mountain, this marker celebrates Mount Killington, Vermont's second-highest peak. Located east of Rutland, the mountain was previously known as Pisgah and is reputedly the site where Rev. Samuel Peters claimed to have named the wilderness "Verd-mont." A stop on the Long Trail and home to a ski resort, the mountain has been called the "Beast of the East" because of its large vertical drop.

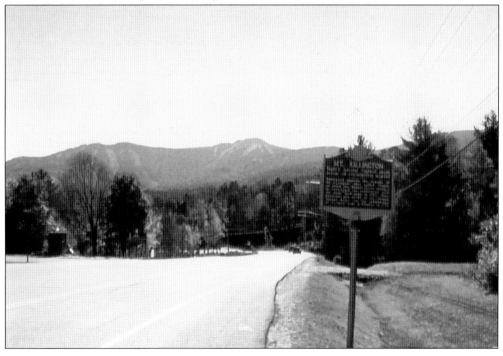

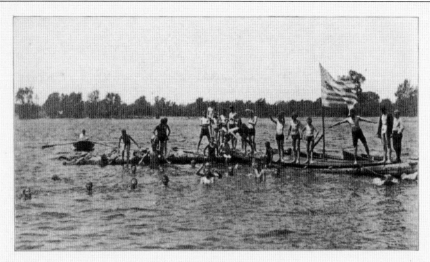

Swimming Hour at Camp Abnaki, Vermont State Y. M. C. A. Camp

Camp Abnaki, founded by Byron "Dad" Clark and named in honor of the Abenaki people, has long offered a summer camp experience for boys. On North Hero, the camp has continued the work for more than 120 years. Operated by the YMCA, the camp's motto is "Help the Other Fellow," emphasizing caring, honesty, respect, and responsibility. Here, campers swim in Lake Champlain.

In South Hero, YWCA Camp Hochelaga has offered girls a similar camping experience for more than 100 years. This undated photograph shows a group of campers with the lake in the background. With core values of collaboration, kindness, leadership, and empowerment, the camp's activities focus on building character, self-esteem, and self-confidence. (Courtesy of the YWCA Camp Hochelaga Alumni Connection.)

Like many historic battlefields, that of Lake George is marked with a monument. Built for the Society of Colonial Wars to commemorate the victory of the colonial forces led by Gen. William Johnson and their allies, the Mohawks led by Chief Hendrick, the monument is unique in that both men are of equal size and stature.

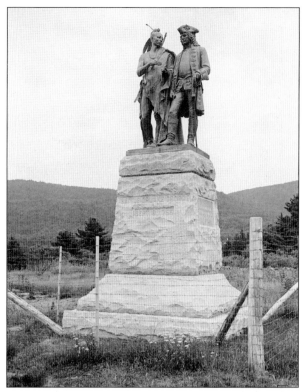

In Plattsburgh's Peace Point Park, a turtle sculpture composed of tiles created by Natasha Smoke Santiago and Emily Kassennisaks Stacey tells the Haudenosaunee Creation Story and recalls the "Words that Come Before All Else" (or "Thanksgiving Address") through symbols. An accompanying interpretive panel offers texts by Mohawk educators Kay Olan and Sue Herne and artwork by John Kahionhes Fadden and David Kanietakeron Fadden of the Six Nations Iroquois Cultural Center.

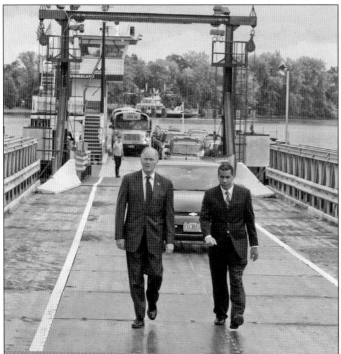

With concerns that the original bridge might collapse, the Champlain Bridge—also known as the Crown Point Bridge—closed in 2009. The next year, Vermont governor James Douglas (left) and New York governor David Paterson walked onto the remaining bridge from the Crown Point ferry to attend the ground breaking of a new bridge between their states.

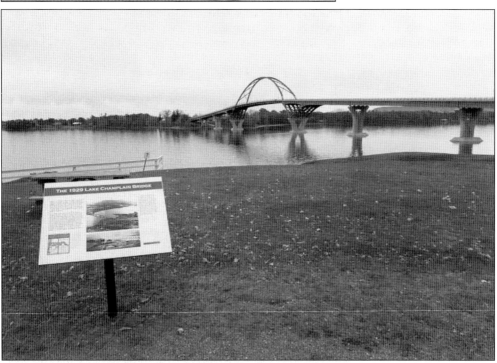

The much-beloved 1929 bridge was listed in the National Register of Historic Places and was nominated as a national historic landmark. Wayside markers like the one shown here recall that earlier history in words and images, leaving room for visitors to admire the new bridge, which opened in 2011. A remnant of a pier was maintained in Vermont near Chimney Point State Historic Site.

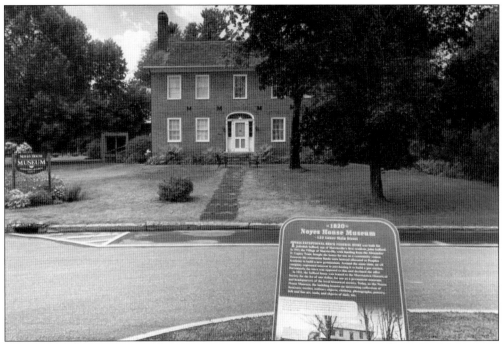

First built in 1797 by John Safford, this house was expanded to a brick, Federal-style structure by his son Jedediah in 1910 and later further renovated to a Victorian style by Carlos Noyes, who purchased the property in 1875. Now occupied by the Morristown Historical Society, the building offers exhibitions that tell the stories of life in Morristown, Vermont, during the 19th and early 20th centuries.

Now the home of Health Funeral Home, this Court Street building in Plattsburgh, New York, was previously the site of a British hospital during the War of 1812 and the Clinton County Historical Association, whose lease expired in 2004. After that point, CCHA moved first to Cumberland Avenue and then to its current location on the Museum Campus of the former Plattsburgh Air Force Base.

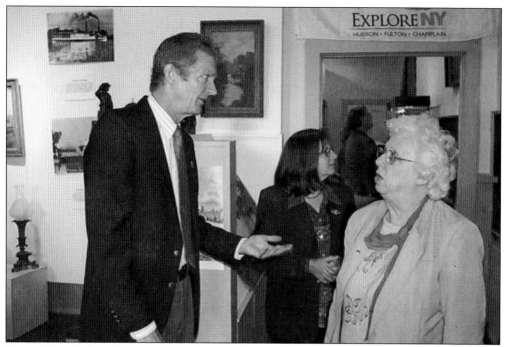

David Hislop Jr. (left) discusses the newly-opened Essex Heritage Center with Janice Allen, Willsboro town historian, in 2009. Located in an 1867 schoolhouse, the center is operated by Historic Essex, an organization created in the 1960s and devoted to preserving the architecture and history of the hamlet, village, and town of Essex.

In 1947, Electra Havemeyer Webb founded the Shelburne Museum, which she intended to be "a collection of collections." She brought buildings, bridges, a train and steamship, and countless objects of art to this museum, which she also populated with the finest examples of local trees, also transplanted to the site. Though not everything at the museum comes from the Champlain Valley, the museum is a local legend. (Courtesy of N. Ravenal.)

Originating just north of the St. Regis River, the Port Kent and Hopkinton Turnpike linked manufacturing interests and promoted the development of the northern Adirondacks. Important both in Port Kent, where this 2020 historic marker is located, and in Hopkinton, where an earlier historic marker is situated, the road was initially made of wooden planks that were eight feet long and three inches thick.

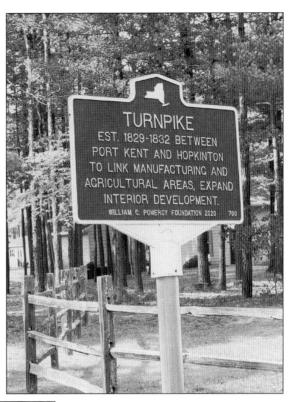

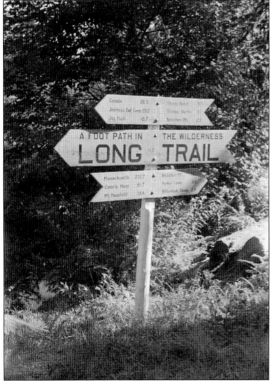

Built by the Green Mountain Club between 1910 and 1929, the Long Trail is the oldest long-distance trail in the country, traversing the Green Mountains via the main ridge from the Massachusetts-Vermont line to the Canadian border. This trail marker in Eden, Vermont, is one of many along the path, which is also marked by a historic marker commemorating the "foot path in the wilderness."

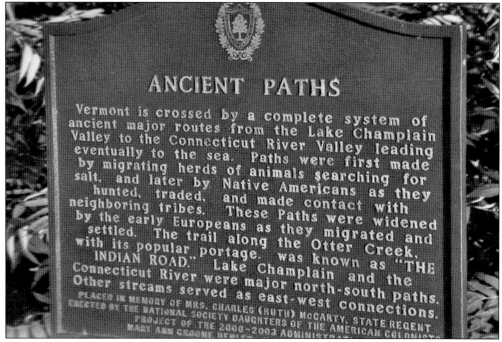

ANCIENT PATHS

Vermont is crossed by a complete system of ancient major routes from the Lake Champlain Valley to the Connecticut River Valley leading eventually to the sea. Paths were first made by migrating herds of animals searching for salt, and later by Native Americans as they hunted, traded, and made contact with neighboring tribes. These Paths were widened by the early Europeans as they migrated and settled. The trail along the Otter Creek, with its popular portage, was known as "THE INDIAN ROAD." Lake Champlain and the Connecticut River were major north-south paths. Other streams served as east-west connections.

PLACED IN MEMORY OF MRS. CHARLES (RUTH) McCARTY, STATE REGENT
ERECTED BY THE NATIONAL SOCIETY DAUGHTERS OF THE AMERICAN COLONISTS.
PROJECT OF THE 2000-2003 ADMINISTRATION.

An older series of paths, created by migrating animals and later used by indigenous peoples, is also remembered in Vermont, with a marker erected by the National Society Daughters of the American Colonists. Many of those paths between the Champlain and Connecticut River Valleys have become the state's major roadways.

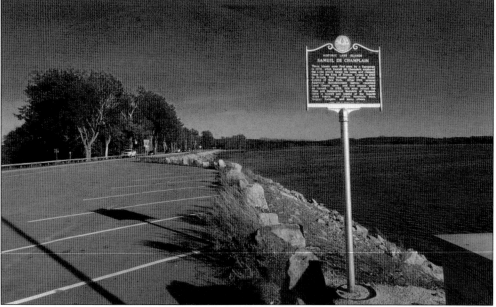

Lake Champlain itself was one of the major paths used by settlers of the area. Beyond giving life to the basin and valley that share its name, the lake connects Vermont to New York and Canada to the United States. Erected in 1965 near he Sandbar State Park, this marker offers a brief history of the explorer, the Champlain Islands, and the state itself.

Four

LOCAL LEGENDS

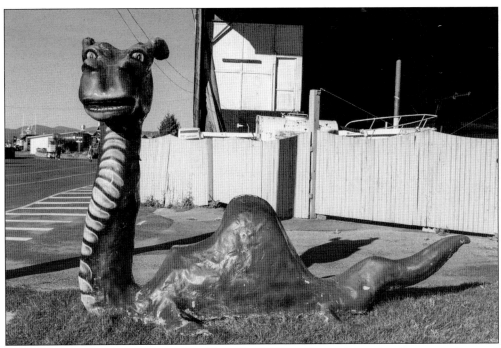

Perhaps the most famous resident of the Champlain Valley is the rarely-seen but frequently-discussed lake monster Champ. Supposedly first documented in Champlain's journals, Champy cheers on his team, the Lake Monsters, in Vermont, graces the signs of many local businesses, and fuels the imaginations of kids, writers, artists, and filmmakers. (Photograph in Carol M. Highsmith's America Project in the Carol M. Highsmith Archive, Prints and Photographs Division, Library of Congress.)

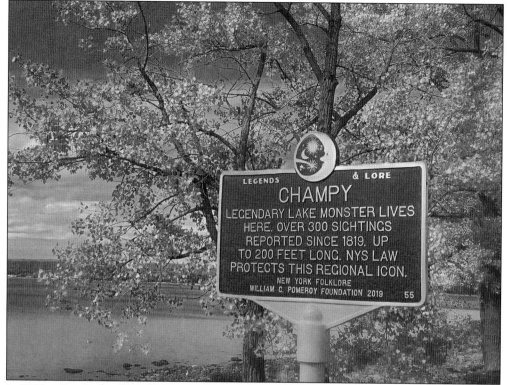

In 2022, a Cumberland Head historical marker sponsored by the William C. Pomeroy Foundation was replaced after it had been stolen the year before. Community members purchased Champy T-shirts and donated to replacing the Legends & Lore sign, a cause that was spearheaded by Town of Plattsburgh supervisor Michael Cashman with the support of the town council and the Clinton County Historical Association.

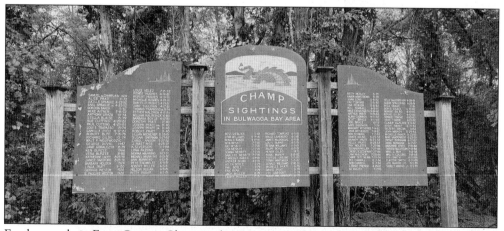

Further south, in Essex County, Champ sightings are recorded on this triptych near Bulwagga Bay, rumored to be the home of the lake monster. The Town of Port Henry, where the bay is located, celebrates Champy every year with a day-long celebration. In 2021, a Legends & Lore marker was erected near this site to share the local story of Champ's creation.

Peter Wolf Toth, a sculptor, created 50 *Whispering Giant* sculptures across the United States as a means of honoring Native Americans and encouraging appreciation of indigenous peoples. This representation of Chief Grey Lock, sculpted from one red oak tree and placed on a base of native red sandstone, was dedicated on July 22, 1984. Although Nature has not always been kind to it, the statue is an iconic part of Burlington's Battery Park.

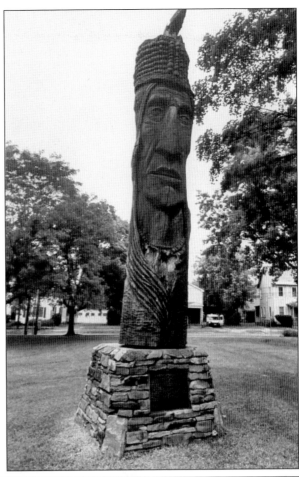

Installed in 2008, this historic marker recalls an indigenous village occupied between the 15th and 17th centuries. Located on the shores of Lake Champlain in Alburg, Vermont, the site's inhabitants, believed to have close ties to the St. Lawrence Iroquois, were identified through thousands of artifacts ranging from smoking pipes to pottery jars.

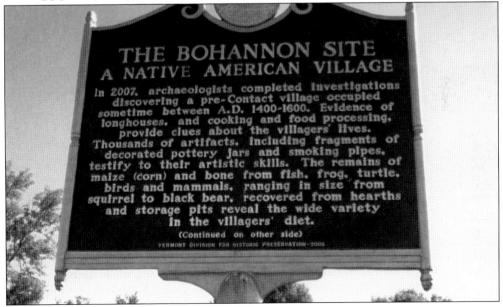

THE BOHANNON SITE
A NATIVE AMERICAN VILLAGE

In 2007, archaeologists completed investigations discovering a pre-Contact village occupied sometime between A.D. 1400-1600. Evidence of longhouses, and cooking and food processing, provide clues about the villagers' lives. Thousands of artifacts, including fragments of decorated pottery jars and smoking pipes, testify to their artistic skills. The remains of maize (corn) and bone from fish, frog, turtle, birds and mammals, ranging in size from squirrel to black bear, recovered from hearths and storage pits reveal the wide variety in the villagers' diet.

(Continued on other side)

VERMONT DIVISION FOR HISTORIC PRESERVATION-2008

Addresses delivered in Ripton, Vermont
on August 20, 1964 at the dedication of
an historical marker honoring

ROBERT FROST

BY

Theodore Morrison and
Edward Hyde Cox

The Friends of the Dartmouth Library

HANOVER · NEW HAMPSHIRE · 1964

Claimed both by New Hampshire and Vermont, the poet Robert Frost taught at Middlebury College's Bread Loaf School of English for almost 41 years. The Ripton farmhouse in which he lived is now owned by the college and acknowledged with a historical marker and by a listing as a national historic landmark.

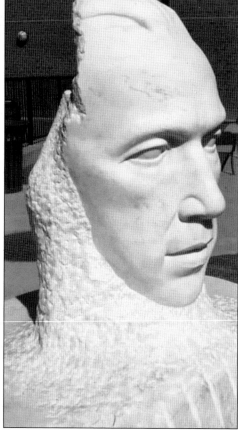

William Griffith Wilson, also known as "Bill W.," cofounded Alcoholics Anonymous in the 1930s. Born in East Dorset, Vermont—where a marker in his honor was erected in 1995—Bill W. is shown here as rendered by sculptor Steve Shaheen and his collaborations. The sixth sculpture placed on the Rutland Sculpture Trail, it is another tribute to the man whose preserved family home receives thousands of visitors each year.

The first woman to practice law in front of the US Supreme Court (1926), as well as the first female Vermont speaker of the house (1953–1955), and the first female lieutenant governor in the country (1955–1957), Consuelo Northrop Bailey of Fairfield, Vermont, is clearly a local legend. Bailey is buried in Sheldon, Vermont.

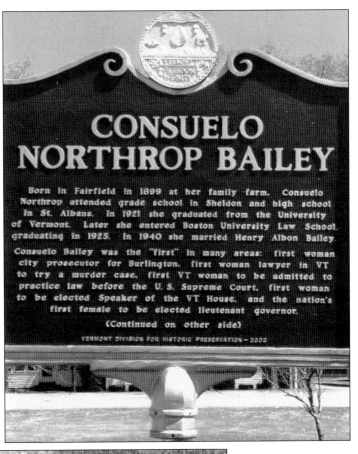

Henry Van Hoevenberg's history in the Adirondacks is storied, to say the least. Besides founding the Adirondack Loj, he mapped countless trails through the mountains and became almost synonymous with the range. Erected in 1968, this marker in North Elba is far from the only reminder of Van Hoevenberg; in fact, a mountain bears his name.

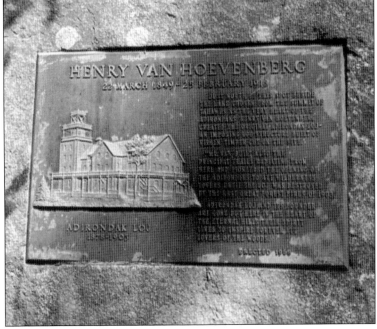

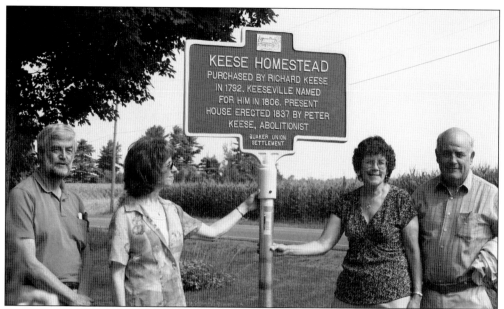

Quakers who lived in Peru and Keeseville, New York, the Keese family were abolitionists believed to have actively participated in the Underground Railroad. They are honored by several markers throughout the region. This marker, which replaced one lost in a traffic accident, was unveiled in 2009. Community members like Neil Burdic and Lita Paczak (left) raised money for the sign, which is maintained by property owners Ann and Lincoln Sunderland (right).

One of few regular army regiments composed of black troops, the 10th US Cavalry Regiment was attached to Fort Ethan Allen in 1909. The arrival of the "Buffalo Soldiers" significantly changed the local landscape, giving rise to fear, prejudice (that took the form of proposals reminiscent of Jim Crow laws in the South), and eventually, for some, acceptance. Their legacy is remembered in historic markers, books, and local museum exhibits.

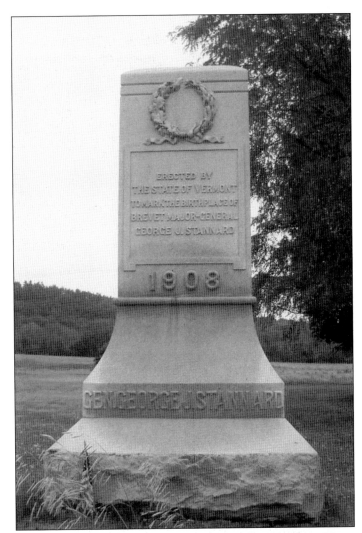

Gen. George J. Stannard was quite possibly the first Vermonter to volunteer to serve in the Civil War and was certainly key to the Union victory at Gettysburg, where he helped to break Pickett's charge. In 1908, Georgia, Vermont, where he was born, recognized him with a stone monument (right). Neighboring town Milton, where Stannard lived and worked, has followed suit. They are restoring Stannard's home, purchased in 1866 after he returned from the Battle of Fort Harrison having resigned due to the loss of his right arm. In 2022, Milton dedicated a historical park in his honor (below).

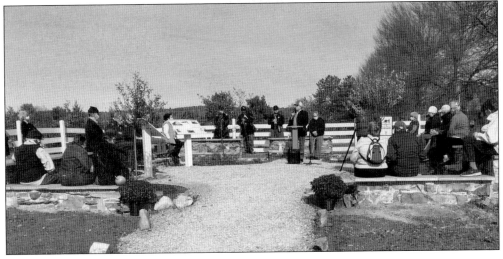

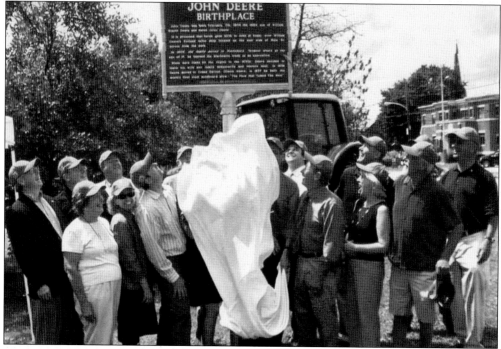

Blacksmith John Deere was born in Rutland in 1804. Although he developed his self-scouring steel plow while living in Illinois, Vermont is proud of this native son, whose invention changed the course of agriculture. In 2012, a historic marker was erected to remember this piece of history and celebrate, in a small way, John Deere Green.

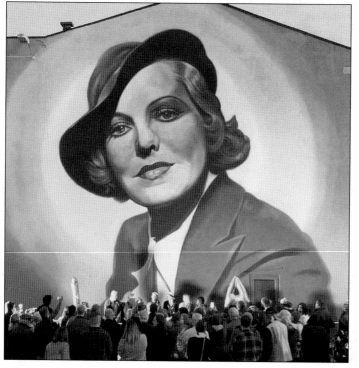

Born Gladys Georgianna Greene in Plattsburgh, Jean Arthur has been commemorated with a historical marker on Oak Street, dedicated in 2014. Eight years later, in 2022, Brendon Palmer-Angell's mural honoring the actress was unveiled a few blocks away. The mural captures Arthur as she was in *Mr. Smith Goes to Washington*. (Photograph by Brian Giebel, courtesy of Outside Art: Plattsburgh's Public Art Project.)

Big Joe Burrell's musical genius and friendly demeanor are legendary in Burlington. Having learned from jazz musicians like Count Basie and B.B. King, Burrell went on to inspire countless other musicians, including Phish's Trey Anastasio. He is remembered in Chris Sharp's 2010 bronze statue on Church Street near Halvorson's, the restaurant where Burrell played his sax every week.

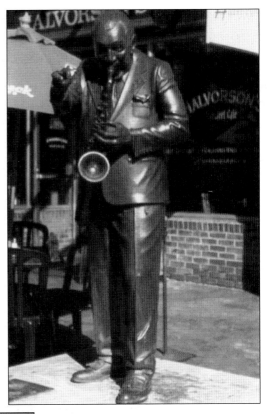

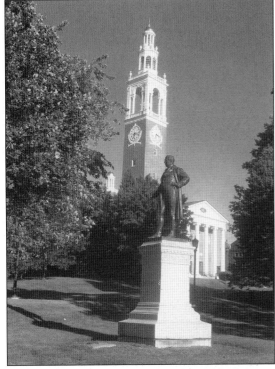

Ira Allen Chapel on the campus of the University of Vermont was named for the university's founder. Designed by the firm of McKim, Mead and White, the chapel is listed in the National Register of Historic Places. The nearby statue of the Marquis de Lafayette, who laid the cornerstone of the Old Mill building in 1825, was dedicated in 1883. (Courtesy of Niranjan Arminius.)

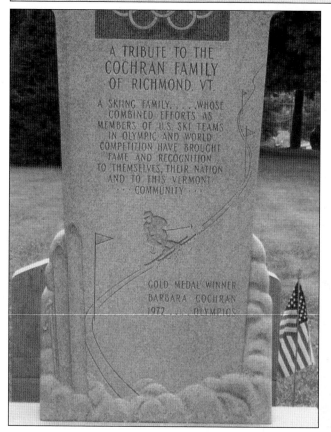

FIRST INTERNATIONAL ICE HOCKEY GAME

In February 1886 the Burlington Coasting Club hosted a week-long Carnival of Winter Sports. In addition to parades and concerts, activities included coasting (bobsledding), ice skating, and snowshoe races. The final event was an ice hockey tournament played on the frozen surface of Lake Champlain. Three teams participated: the Montreal Hockey Club; the Crystal Hockey Club, Montreal; and the Van Ness House, Burlington. On February 26, 1886, the Montreal Hockey Club defeated the Van Ness House 3-0 in the first documented ice hockey game played between teams from different countries. The Montreal Hockey Club went on to win the first Stanley Cup in 1893.

(En francais de l'autre côte)

VERMONT DIVISION FOR HISTORIC PRESERVATION - 2019

A TRIBUTE TO THE
COCHRAN FAMILY
OF RICHMOND, VT.

A SKIING FAMILY.....WHOSE
COMBINED EFFORTS AS
MEMBERS OF U.S. SKI TEAMS
IN OLYMPIC AND WORLD
COMPETITION HAVE BROUGHT
FAME AND RECOGNITION
TO THEMSELVES, THEIR NATION
AND TO THIS VERMONT
··· COMMUNITY ···

GOLD MEDAL WINNER
BARBARA COCHRAN
1972 ... OLYMPICS

In the Champlain Valley, hockey is an extremely important part of athletic culture, moving beyond a winter sport to one supported by indoor rinks throughout the region. This historic marker, erected by the Vermont Division for Historic Preservation in 2019, recalls the first international hockey game. The Montreal Hockey Club, which went on to win the first Stanley Cup in 1893, won this match with the Van Ness House team.

Skiing, too, is an important local winter activity and industry. This marker remembers the "Skiing Cochrans," four siblings and many of their children, who have vied for glory in the Olympics, world championships, and World Cup. Barbara Cochran, who specialized in the slalom and giant slalom, won gold at the 1972 Olympics.

William Lawrence "Larry" Gardner excelled in a summer sport, baseball. Born in Enosburg, Gardner first played in a Franklin County league and then went on to play for the University of Vermont before turning pro and playing with the Boston Red Sox. The third baseman, who helped the Sox win the 1912, 1915, and 1916 World Series, was honored by a marker at his birthplace in 1996.

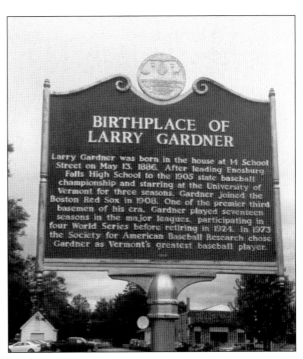

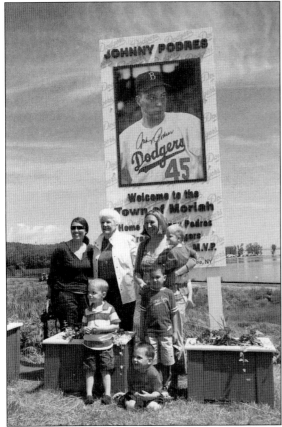

Across the lake, Witherbee commemorated its hometown baseball hero on August 6, 2011, declaring it Johnny Podres Day. The pitcher led the Brooklyn Dodgers to victory over the New York Yankees in the 1955 World Series. Visitors to the Moriah–Port Henry area are reminded of him with this sign, shown here surrounded by Podres's wife, daughters, and grandchildren after it was first unveiled.

MILTON SPEEDWAY

On June 23, 1963, Maurice Bousquet and Hubert "Bud" McCormick of Milton's B&M Motors, with top Vermont driver Jack DuBrul of Burlington, opened Vermont's first drag strip here before a capacity crowd.

Known by the locals as Milton Drag Strip, the NASCAR-sanctioned quarter-mile track provided a new source of entertainment and, to the delight of police, a safer place to race than Milton's public roads.

Milton Speedway ran a weekly program with local and regional drivers. Match races and other special shows were featured, such as Walt Arfons' "Bonneville Avenger" jet dragster in June 1966. National stars such as Jack and Shirley "Cha Cha" Muldowney and "Big Daddy" Don Garlits raced here.

Milton Speedway's final competitions were held in 1971.

VERMONT DIVISION FOR HISTORIC PRESERVATION - 2019

Racing is another regional sport of great importance. In Milton, two tracks—Milton Speedway and Catamount Stadium—have been remembered with historical markers. Catamount Stadium opened on June 11, 1965, with 4500 people in attendance. Its one-third-mile track was sanctioned by NASCAR; after a storied history that included appearances by national drivers like Richard Petty, Darrell Waltrip, Bobby Allison, Benny Parsons, and Tiny Lund, and regular appearances by hometown heroes Bobby and Harmon "Beaver" Dragon, the track closed in 1987 and is remembered by a marker erected in 2018. Two miles away, Milton Speedway, in operation from 1963 to 1970, offered a quarter-mile, NASCAR-sanctioned track. Weekly programs with local and regional drivers allowed a safer alternative to the drag races that had previously occurred on local streets. Here, Hubert "Bud" McCormick, one of Milton Speedway's founders, shakes hands with Norm Monette, a driver known as "the Flying Farmer" at the dedication of a historical marker in 2019.

1947 Sprint Race Car

- Owned and raced by Jackie Peterson, Local Racing Icon who raced at Airborne Speedway.
- Jackie won the first Airborne Speedway Championship in 1954
- This is a reproduction of the original car built in 1947
- This car built by Jackie Peterson, Clement Couture, and Charlie Provost.

John "Jackie" Peterson and his friends Clement Couture and Charlie Provost spent more than 1,000 hours reproducing the 1947 sprint race car with which Peterson began his storied racing career. For over 16 years, he raced at more than 40 tracks, including in Airborne Speedway's first race. The original car, built after World War II, had five different engines, including a Ford Model A and a six-cylinder Hudson, over the course of its lifetime. This reproduction was on display at the Champlain Valley Transportation Museum until its closure during the COVID-19 pandemic. Peterson raced to legendary status at Airborne Speedway in Plattsburgh. Only one of many local racetracks, Airborne, named for its proximity to the local Air Force base, opened in 1954 and has been in operation ever since. Other Valley speedways still in operation include Thunder Road in Barre (opened 1960), Devil's Bowl in Westhaven, Vermont (1967), Mohawk International Raceway in Hogansburg, New York, and Bear Ridge Speedway in Bradford, Vermont. A different kind of racing—horse and greyhound—was part of Pownal, Vermont's, landscape from 1963 to 1993, with the Green Mountain Racetrack welcoming racers and spectators.

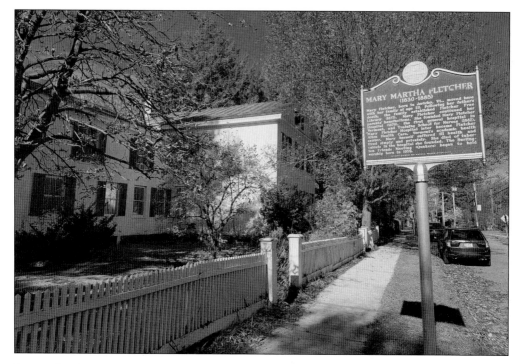

Born in Jericho, Vermont, Mary Martha Fletcher moved to this Burlington home (above) in 1850. Known for their philanthropy, the Fletcher family endowed many public institutions, including the Mary Fletcher Hospital (below). Although named in her honor, Mary Fletcher, who did not live to see it completed, wished for the hospital to honor her parents, saying, "It was their money, not mine that I gave. I wish to be remembered hereafter simply as one who had an obligation and tried to fulfill it; as one who had work to do and tried to do it as well as a poor sick woman could." Although the hospital no longer bears her name, she looms large in its history as a training hospital for nurses and a place for Vermont's citizens to receive care.

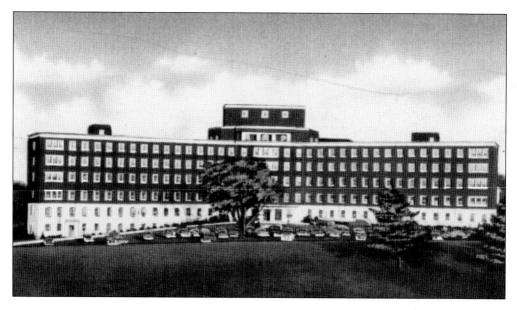

Nearby, the Fletcher Free Library offers another testament to the philanthropic Fletcher family. Endowed by a gift of $20,000, the library was originally located in Burlington's old city hall building. A 1901 gift from Andrew Carnegie made it possible for this new library, dedicated in 1904, to be built. Local commitment to the library developed into a push to save the building, which was restored and expanded in the early 1980s.

Another local businessman, William Gove Bixby, made a similar offering to his hometown of Vergennes, Vermont. The majority of his estate was left to create a public library, the cornerstone of which was laid in 1911. Immediately after it opened in 1912, community members began signing up for library cards and the library became a much-loved community center. (Wikimedia/Gopats92.)

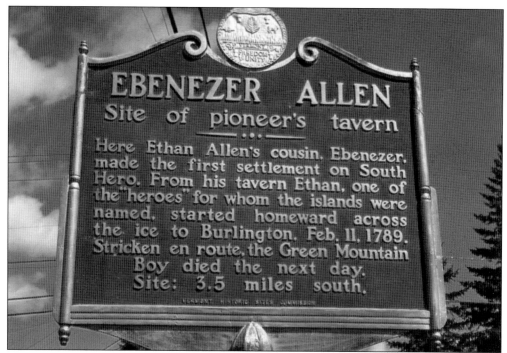

Named for the Allen brothers, South Hero Island was long the home of their cousin, Ebenezer, who built a tavern on the site where this marker is located and who was himself a Vermont politician. One of the founders of Poultney, Vermont, Ebenezer Allen was a lieutenant in the Green Mountain Boys.

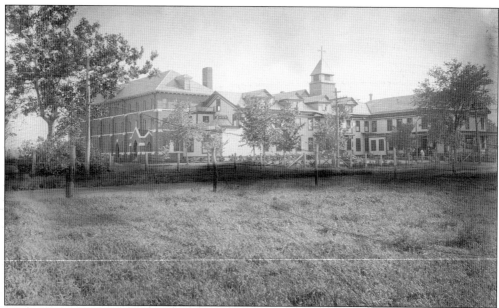

The daughter of Ethan Allen, Frances Margaret "Fanny" Allen is said to be the first New England woman to become a Catholic nun. She is more famous, however, for her work with the Religious Hospitallers of St. Joseph, who named their hospital and nurse's school in Colchester, Vermont, after her.

Although his family was poor, Henry Crandall used the fortune he amassed through his work as a lumberman to fund a local library, park, and Boys Club in the hope of helping those less fortunate. The Crandall Memorial, in Crandall Park, is not the only Glens Falls marker honoring the philanthropist.

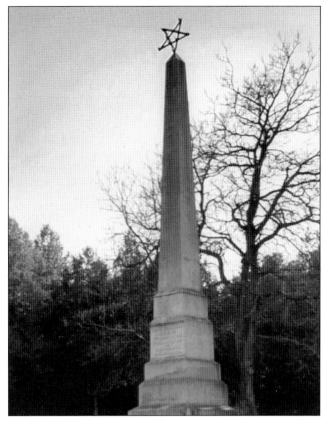

Georgia O'Keeffe, with her husband Alfred Stieglitz, visited the shores of Lake George often between 1918 and 1934, capturing the beauty and history of the place in more than 200 paintings. In 2016, the William G. Pomeroy Foundation erected two markers, one roadside and one lakeside, in honor of the artist who stayed at Wakonda in 1908. Another marker honoring both artists was erected by the Lake George Arts Project.

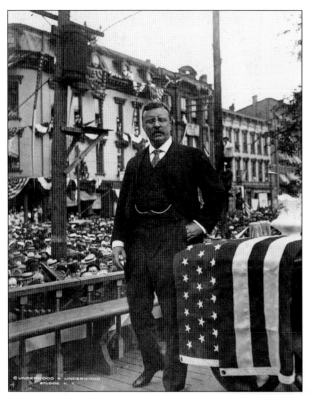

Theodore Roosevelt looms large in the Champlain Valley's heritage and features in many historical markers. As governor of New York, Roosevelt made many trips to the region, often to review troops at the Plattsburgh Barracks. During the tercentenary year, he participated in numerous ceremonies throughout the region. In 1901, he learned of McKinley's death and his succession to the presidency while vacationing in the Adirondacks.

The "Little Giant" Stephen Douglas was born in Brandon, Vermont, in 1813. Although his career brought him to Illinois, where he gained fame as a politician and most notably as Abraham Lincoln's opponent for the presidency in the 1850s, his hometown honored him with a historical marker in 1957 and with matching pedestals and markers, one of which is shown here, in 1913.

Grace Goodhue, a graduate of the University of Vermont and teacher at the Clark School for the Deaf in Massachusetts, married Calvin Coolidge at her parents' home in Burlington in October 1905. Voted one of America's 12 greatest living women in 1931, she was reputed to be a model first lady and an admirable person.

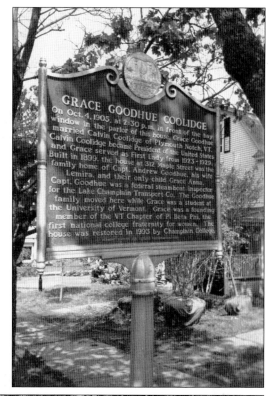

In Fairfield, Chester Arthur's homestead stands as a testament to the 21st president of the Union. Although he grew up in Schenectady, New York, Vermonters take pride in this native-born son whose early legal cases promoted civil rights and who served as the quartermaster of New York's state militia during the Civil War.

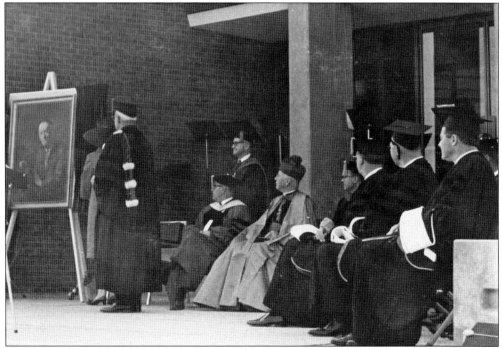

Named for Rev. Louis M. Cheray, a founder of the college, Cheray Hall was dedicated in this ceremony on May 15, 1949. In Vermont, the priest taught math and theology. He returned to his native France to enlist during World War I, only to return to his St. Michael's College teaching responsibilities again after the war. A plaque in his honor remains on the science building. (Courtesy of the Saint Michael's College Archives, Saint Michael's College, Colchester, Vermont.)

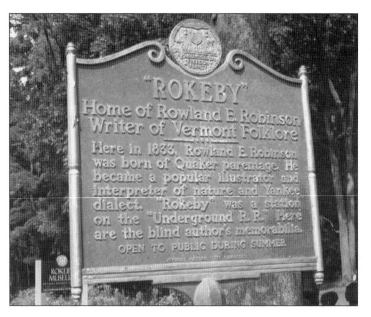

The Rokeby Museum in Ferrisburgh, Vermont, is dedicated to providing a vision of the human experience of the Underground Railroad. The Robinson family, who lived here from 1793 to 1961, were committed abolitionists. Rowland E. Robinson, who was born here to Rowland T. and Rachel Gilpin Robinson, Quakers who vociferously opposed slavery, is remembered for preserving Vermont folklore in a marker near the museum's entrance.

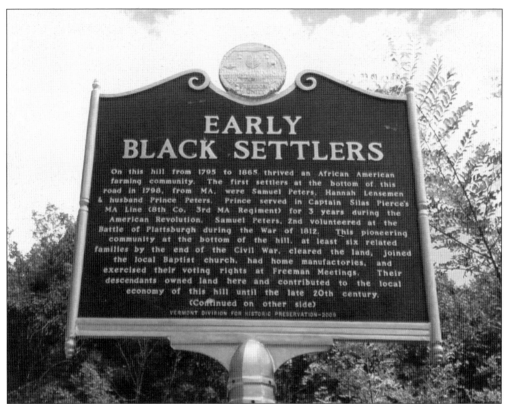

On this hill from 1795 to 1865 thrived an African American farming community. The first settlers at the bottom of this road in 1798, from MA, were Samuel Peters, Hannah Lensemen & husband Prince Peters. Prince served in Captain Silas Pierce's MA Line (8th Co. 3rd MA Regiment) for 3 years during the American Revolution. Samuel Peters, 2nd volunteered at the Battle of Plattsburgh during the War of 1812. This pioneering community at the bottom of the hill, at least six related families by the end of the Civil War, cleared the land, joined the local Baptist church, had home manufactories, and exercised their voting rights at Freeman Meetings. Their descendants owned land here and contributed to the local economy of this hill until the late 20th century. (Continued on other side)

Sadly, too many people of color are not remembered by name in local historical accounts. This marker is one of several attempts to recall their history, though the record is incomplete. Erected near Hinesburg in 2009, it recalls an African American farming community that thrived here between 1795 and 1865. Many of the people who lived and worked here are buried in an abandoned cemetery at the top of the hill.

In 1866 and 1870, members of the Fenian Brotherhood, a branch of the Irish Republican Army composed of immigrants to the United States who served in the Civil War, fought against the British army in Canada, making it as far south as St. Albans before being stopped. These local raids left a couple of Fenians dead and ended with an Irish retreat.

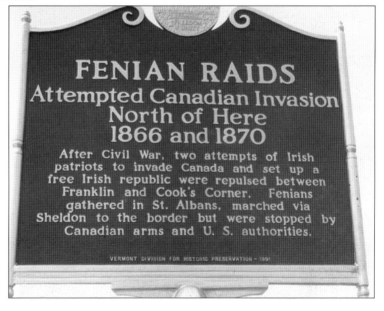

FENIAN RAIDS
Attempted Canadian Invasion
North of Here
1866 and 1870

After Civil War, two attempts of Irish patriots to invade Canada and set up a free Irish republic were repulsed between Franklin and Cook's Corner. Fenians gathered in St. Albans, marched via Sheldon to the border but were stopped by Canadian arms and U. S. authorities.

VERMONT DIVISION FOR HISTORIC PRESERVATION - 1991

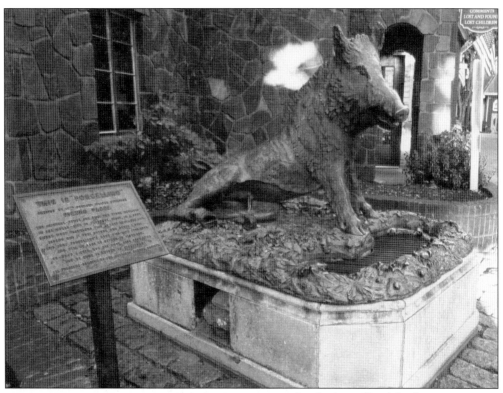

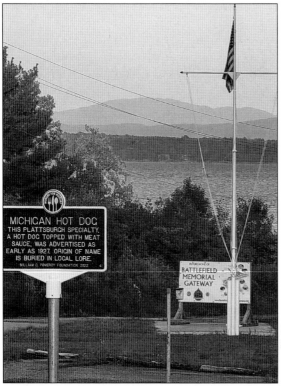

Inside the walls of the former Storytown, now Six Flags Great Escape, *Porcellino* greets visitors. Legend says that visitors who drop a coin and rub the nose of this replica of an Italian statue will ensure good fortune. A similar version of *Porcellino* in the village of Lyndonville, Vermont, known both as the "Barfing Boar" or "Puking Pig," is presumably less lucky.

Alongside the vibrant natural beauty and the military history of the lake, one historical marker bears witness to a local delicacy also celebrated in the Town of Plattsburgh's Michigan Month. The exact origin of the local dish, which pairs a spicy meat sauce with a hot dog, is unknown, but its local significance will not be forgotten.

Five

SOLEMN REMEMBRANCES

A sculpted metal figure of a fiddler with a broken violin stands between the Ohavi Zedek Synagogue, a stone bench placed in honor of Rabbi Joshua and Katharine Chasan, and a matzevah monument commemorating all of the Jewish people who perished in the Holocaust. This congregation, formed in 1885, has also saved the *Lost Mural*, referred to as an "accidental survivor of the holocaust."

Each year, the Essex County Task Force Against Domestic Violence hosts a Day of Remembrance to mourn those lost to domestic violence, celebrate those who have survived, and bring together those who support the victims. Here, students from AuSable Valley High School look at some of the 140 T-shirts created by victims of domestic violence exhibited in 2009. (Photograph by Alvin Reiner, courtesy of the *Plattsburgh Press-Republican*.)

The Clinton County Victims Advocacy Center, which operated from the Probation Department from 1996 until grant funding was discontinued in 2014, erected this nondescript marker for victims of crime in Plattsburgh's Heritage Plaza. Remembering victims and helping them to understand their legal rights, advocate for themselves through the legal process, find counseling services, and prepare victim impact statements are essential ways for those affected by crime to move forward.

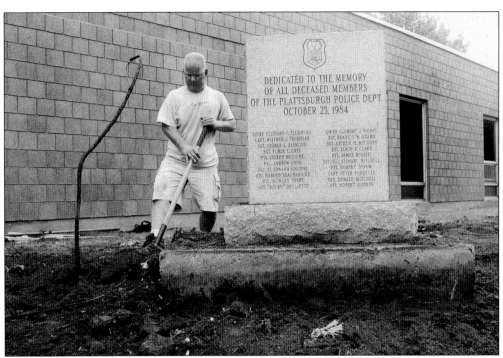

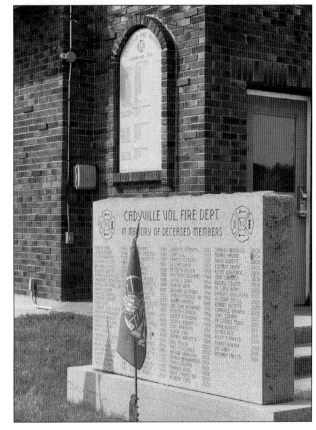

Lt. Pat Rascoe is shown clearing the area surrounding the 1984 monument to deceased members of the Plattsburgh Police Department. By 2008, another stone was needed to continue remembering those who served the community. Similar monuments, which memorialize and express gratitude for service, may be found throughout the Champlain Valley. (Photograph by Michael Betts, courtesy of the *Plattsburgh Press-Republican*.)

In Cadyville, New York, a similar marker, erected in memory of deceased members of the volunteer fire department, stands next to the firehouse. On the wall behind the stone is a tablet with the names of various commissioners and officers of the district, which was established in 1952. Throughout the Champlain Valley, volunteer firefighters augment the efforts of the few paid fire departments.

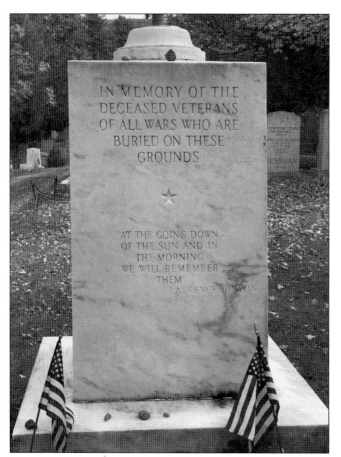

This marker in the Jewish cemetery of Clarendon, Vermont, remembers those who served in wars. At the bottom of the stele are words from Robert Laurence Binyon's poem, "For the Fallen": "At the going down of the sun and in the morning we will remember them." Visitors to the cemetery have left small stones on the marker as a sign of respect.

Pictured at the rededication ceremony in 2021, the Fallen Heroes Monument at Camp Johnson in Colchester stands as a testament to those who died in service to the United States. Moved from a location on the Vermont National Guard base to a more accessible location outside the facility's gates, the ceremony asked participants to never forget "those who gave their last full measure of devotion."

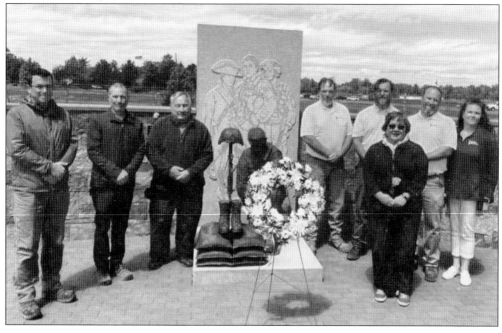

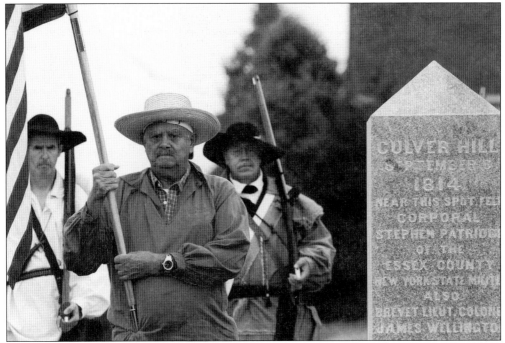

Each year, Beekmantown commemorates the activities at Culver Hill on the bloodiest day of the British army's campaign to capture Plattsburgh in 1814. Dedicated by the Plattsburgh Institute in 1894, this monument remembering those who fought and died here is now the focal piece of the Culver Hill Historic Park, dedicated in 2008. (Photograph by Kelly Catana, courtesy of the *Plattsburgh Press-Republican*.)

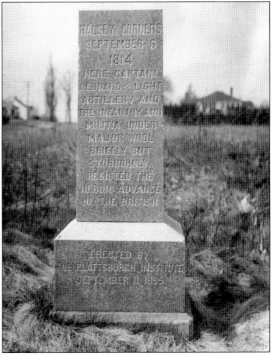

After engagements at Beekmantown and Culver Hill, Maj. John E. Wool staged a fighting retreat to Plattsburgh, where he was joined by Captain Leonard and two three-pound cannons. Those who died at Halsey's Corner are remembered by annual ceremonies held at this marker, erected in 1895 by the Plattsburgh Institute, whose students were among the American volunteers. (Courtesy of the Clinton County Historian's Office.)

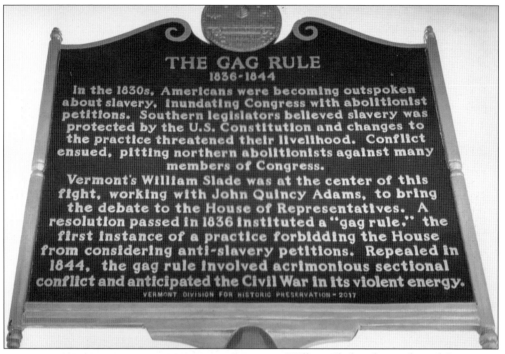

THE GAG RULE
1836-1844

In the 1830s, Americans were becoming outspoken about slavery, inundating Congress with abolitionist petitions. Southern legislators believed slavery was protected by the U.S. Constitution and changes to the practice threatened their livelihood. Conflict ensued, pitting northern abolitionists against many members of Congress.

Vermont's William Slade was at the center of this fight, working with John Quincy Adams, to bring the debate to the House of Representatives. A resolution passed in 1836 instituted a "gag rule," the first instance of a practice forbidding the House from considering anti-slavery petitions. Repealed in 1844, the gag rule involved acrimonious sectional conflict and anticipated the Civil War in its violent energy.

VERMONT DIVISION FOR HISTORIC PRESERVATION · 2017

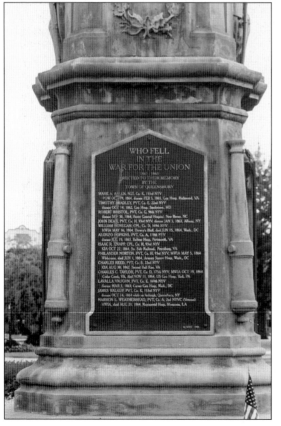

William Slade, who graduated from Middlebury College in 1807, was a lawyer and politician whose abolitionist beliefs led him to oppose the gag rule established in the US House of Representatives. In defiance of the rule, Slade proceeded with a speech on the history and inhumanity of slavery. This Cornwall, Vermont, marker was erected in 2017.

Almost every community in the Champlain Valley has a Civil War monument, many of which take the form of obelisks. Here is a close-up of one such statue in Glens Falls, New York. Erected by the Town of Queensbury in remembrance of those who fell in "the war for the Union," the marker clearly delineates the allegiance of the town during and after the war.

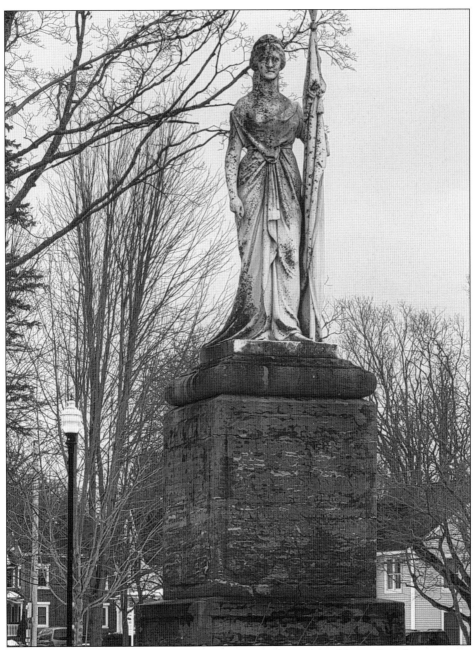

Lying in the center of Swanton, an 1868 monument within a wrought-iron fence bears witness to the community's dedication to "her patriot soldiers who fell in the War of the Rebellion." With an initial cost of $2,000, the statue, made of white marble quarried in Rutland, displays the figure of the Grecian goddess Liberty atop a base made of marble from the local Fisk and Barney Quarry in Isle la Motte. Thanks to a preservation grant and local fundraising, the monument, which was made by town native Daniel J. Perry, was restored in 1995. In recent years, the park near the statue has been the site of the town's Flags for Veterans installation, in which a flag is placed in the park for each of the municipality's veterans, with a roster of the individuals honored both on site and on the town's website.

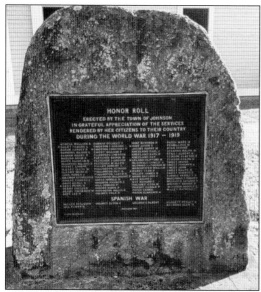

This honor roll "in grateful appreciation of the services rendered by her citizens to their country" was erected in Johnson, Vermont, and emblazoned with the names of those who served in World War I and in the Spanish–American War. The marker is near a similar 1921 installation recognizing Civil War Veterans.

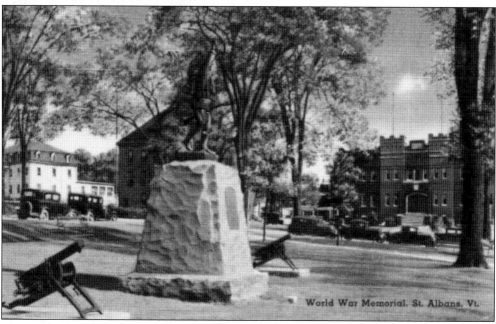

The Enosburg Doughboy has stood in Lincoln Park, honoring the service of 81 men from Enosburg Falls who served in World War I, since 1930. One of two remaining Vermont statues based on Ernest Moore Viquesney's *The Spirit of the American Doughboy*, designed in 1920, this soldier stands with his right arm raised, grenade in hand while his left hand holds a bayoneted rifle. The flat steep helmet, trousers that blouse above the knee with wrapped leggings below, rectangular bedroll backpack with bayonet scabbard, square gas mask pouch on his chest, cartridge belt, canteen, mess kit, and first-aid kit indicate that this man—and the many he represents—is an American infantryman, known as a doughboy during the war. Stumps on the ground and the hint of barbed wire at the rear remind us that he fought in the trenches. In 2021, a crack in this doughboy's foot was fixed by Colchester's East Coast Copper and the statue was back in place for the Veterans Day ceremony in Lincoln Park.

This monument honoring the service of Wheelock, Vermont, men in World War I is more unique. A stone marker with scalloped markings that radiate from a central plaque lists the names of 14 residents who were among the more than 14,000 Vermont men who served. Lawrence Blodgett and Monte Fuller, two of the Caledonia County citizens who fought, died in service.

Within sight of the town's Civil War monument, on a long expanse of lawn that also holds two other monuments and a cannon, the Coventry, Vermont, World War I marker remembers 18 men who left home to fight for their country, proclaiming from a central location in town, "their name liveth for evermore."

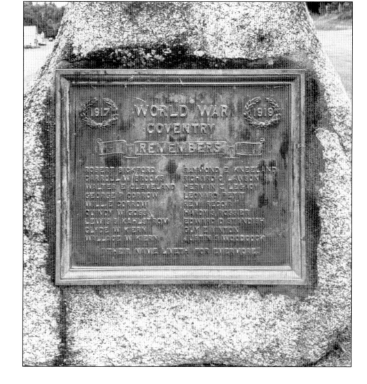

Each year, the local post of the Veterans of Foreign Wars holds Veterans Day services in Burlington's Battery Park. The site shown here is home to a memorial dedicated to Howard W. Plant, who was the first Burlington boy to die in World War I and for whom VFW Post No. 782, the Howard Plant Post, is named. The 1957 ceremony marked the 40th anniversary of his death.

Although the design of the markers changed, the spirit did not, as seen in this Colchester monument to those who served. In front of the Burnham Memorial Library, the marker complements individual markers attached to veterans' graves. At least one local man, Lt. Richard J. Heh, was held as a prisoner of war during World War II.

Clarendon's World War II Honor Roll is a simple yet moving tribute to those who served in World War II. The Rutland County town known as the "Crossroads of Vermont" lists the names of its veterans alphabetically. Touchingly, the monument includes two Gold Star Mothers, Deborah Grover and Beulah Nichols, both of whom lost their sons to the war.

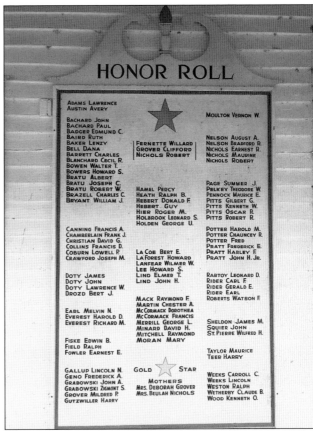

HONOR ROLL

Adams Lawrence		
Austin Avery		Moulton Vernon W.
Bachard John		
Bachard Paul		Nelson August A.
Badger Edmund C.		Nelson Bradford R.
Baird Ruth	Fernette Willard	Nichols Earnest R.
Baker Lenzy	Grover Clifford	Nichols Maurine
Bell Dana	Nichols Robert	Nichols Robert
Barrett Charles		
Blanchard Cecil R.		
Bowen Walter T.		
Bowers Howard S.		Page Summer J.
Bratu Albert		Pelkey Theodore W.
Bratu Joseph C.	Hamel Percy	Pennock Maurice E.
Bratu Robert W.	Heath Ralph B.	Pitts Gilbert G.
Brazell Charles C.	Hebert Donald F.	Pitts Kenneth W.
Bryant William J.	Hebert Guy	Pitts Oscar R.
	Hier Roger M.	Pitts Robert R.
	Holbrook Leonard S.	
	Holden George U.	
Canning Francis A.		Potter Harold M.
Chamberlain Frank J.		Potter Chauncey R.
Christian David G.		Potter Fred
Collins Francis D.		Pratt Frederick E.
Coburn Lowell P.	La Coe Bert E.	Pratt Harley F.
Crawford Joseph M.	La Forest Howard	Pratt John H. Jr.
	Lanfear Wilmer W.	
	Lee Howard S.	
Doty James	Lind Elmer T.	Rabtoy Leonard D.
Doty John	Lind John H.	Rider Carl F.
Doty Lawrence W.		Rider Gerald E.
Drozd Bert J.		Rider Earl
	Mack Raymond F.	Roberts Watson F.
	Martin Chester A.	
Earl Melvin N.	McCormack Dorothea	
Everest Harold D.	McCormack Francis	
Everest Richard M.	Merrill George L.	Sheldon James M.
	Minard David H.	Squier John
	Mitchell Raymond	St. Pierre Wilfred H.
Fiske Edwin B.	Moran Mary	
Field Ralph		Taylor Maurice
Fowler Earnest E.		Teer Harry
Gallup Lincoln N.	Gold ★ Star	Weeks Carroll C.
Geno Frederick A.	Mothers	Weeks Lincoln
Grabowski John A.	Mrs. Deborah Grover	Weston Ralph
Grabowski Zigmont S.	Mrs. Beulah Nichols	Wetherby Claude B.
Grover Mildred P.		Wood Kenneth O.
Gutzwiller Harry		

Throughout the Champlain Valley, Veterans Day is commemorated with parades and ceremonies like this one in Barre, Vermont. Set against the backdrop of the 1920s war memorial *Youth Triumphant*, Vietnam veteran Ronald Tallman reminded the crowd that "each one of us can defend freedom by voting and speaking out against injustices."

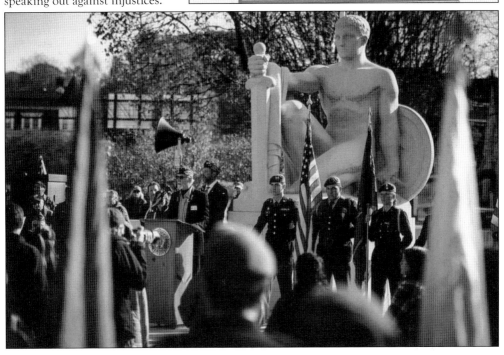

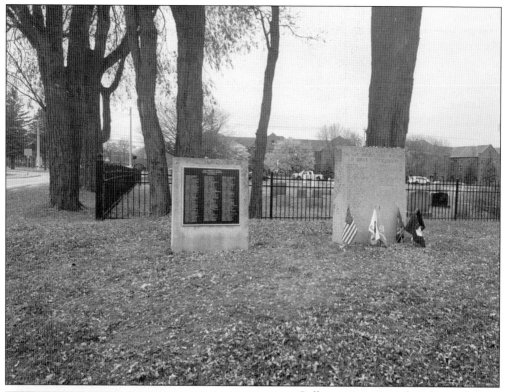

Colleges, too, remember those who served. A small park next to a fenced-in cemetery commemorates the members of the Saint Michael's family who died in service to their country, as well as the people who supported the Military Heritage Memorial. The men listed graduated from the college from its creation until 1971.

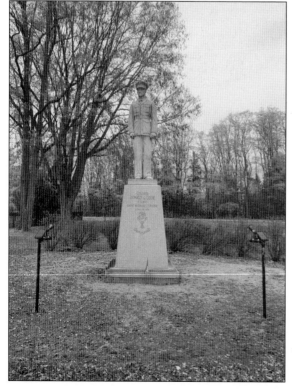

One St. Michael's alumnus, Col. Donald G. Cook, who graduated in 1956, has a nearby monument dedicated solely to him. Cook, a US Marine, was held prisoner by the Viet Cong from 1964 until he died of malaria in 1967 at the age of 33. Officially declared dead in 1980, Cook was awarded the Medal of Honor posthumously by the secretary of the Navy.

Most Veterans of Foreign Wars posts in the Champlain Valley have a monument to their members. This brick wall in Peru, New York, offers flags to honor each branch of the service and to remember prisoners of war and those missing in action. Engraved with the names of those who have died, the wall is constructed, in essence, with their memories.

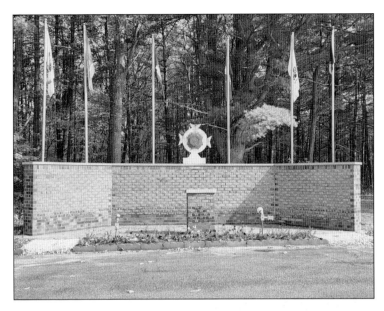

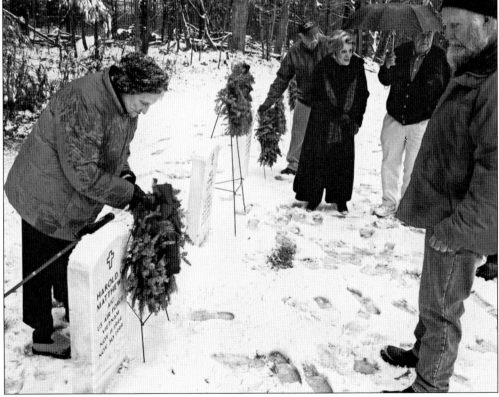

Every December, communities across the nation lay wreaths on veterans' graves as part of the Wreaths Across America campaign to remember, honor, and teach. This 2010 photograph shows men and women laying wreaths as part of the Elizabethtown-Lewis American Legion Post ceremony at the Essex County Cemetery near Wadhams. (Photograph by Alvin Reiner, courtesy of the *Plattsburgh Press-Republican*.)

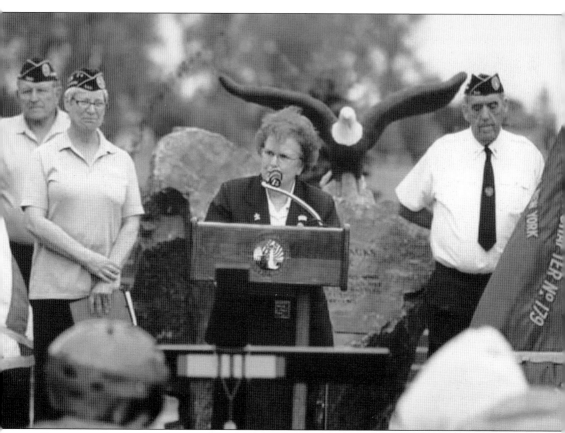

Expressing the thanks of a grateful nation, former New York state legislator Janet Duprey speaks at a ceremony at the Plattsburgh Barracks Veterans Park. The North County Honor Flight was organized to honor the men and women who left their homes and families to fight on foreign soil, and who gave so much in service to us all. Recognizing veterans from northern New York and Vermont, the organization is a source of great pride in the Champlain Valley, one that lives out Pres. Harry Truman's words, "Our debt to the heroic men and valiant women in the service of our country can never be repaid. They have earned our undying gratitude. America will never forget their sacrifices." With donations and the proceeds of various fundraisers, each trip brings veterans and guardians responsible for their comfort and safety from Plattsburgh to Washington, DC, and back in a single day. Ceremonies start early in the day and are continued, on a smaller scale, at the war memorials in Washington.

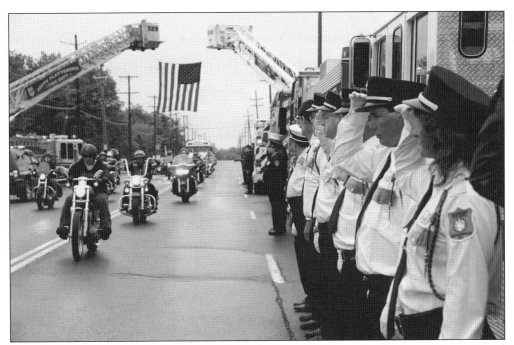

The Combat Vets Motorcycle Association leads the Honor Flight to the Plattsburgh International Airport, driving through a street lined with members of the Morrisonville Volunteer Fire Department. Six area fire departments and rescue crews joined these men and women, saluting local World War II veterans being honored in 2013. (Photograph by Rachel Moore, courtesy of the *Plattsburgh Press-Republican*.)

At the 2013 ceremony to honor World War II veterans going on the Honor Flight to Washington, DC, veteran Ralph Tefft (left) greets Brian Tromblee, member of the Combat Vets Motorcycle Association Chapter XO. Tefft was one of 18 veterans traveling to the capital in this inaugural year of the program. Since then, more than 645 veterans of World War II, Korea, and Vietnam have been honored.

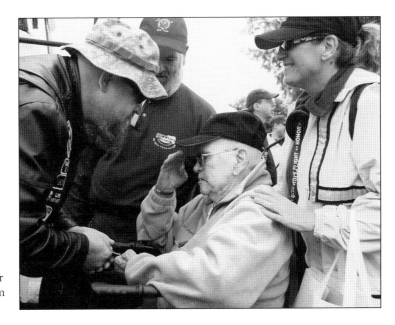

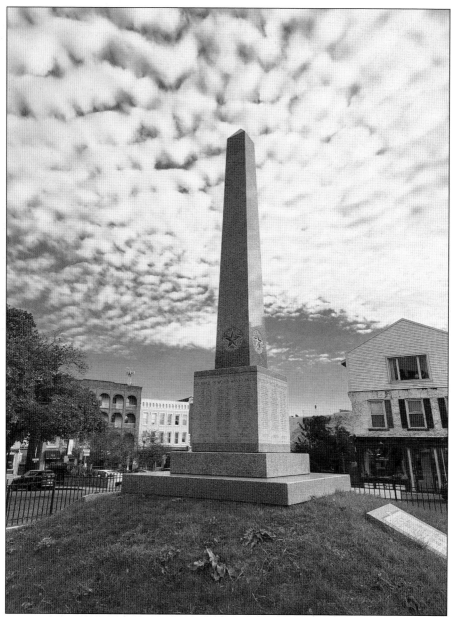

On December 10, 1950, the Gold Star Mothers Monument, a stone obelisk with two ground tablets made of stone on the east and west sides, was dedicated to the memory of those "who made the supreme sacrifice in World Wars I and II." Nestled in Trinity Park between the Clinton County Government Center and the McDonough Monument, the site evolved to include the names of those lost in later conflicts. In Northfield, Vermont, on the campus of Norwich University, a different sort of memorial was dedicated in 2017. Support from the Hershel "Woody" Williams Medal of Honor Foundation allowed for the erection of the Gold Star Families Memorial Monument, "a tribute to Gold Star families and relatives who sacrificed a loved one for our freedom." Both monuments share a commitment to remembering those lost, recalling the words of Georgie Carter-Krell, whose son was a posthumous Medal of Honor recipient: "Dying for freedom isn't the worst thing that can happen. Being forgotten is."

After losing her son in 1918, Grace Darling Seibold organized the Gold Star Mothers as a means of turning her grief into positive action. The group, which was eventually chartered in 1929, provides comfort to its members and assistance to wounded veterans. Eventually, membership was expanded to include mothers who lost their children in service to the United States during any conflict. In Clinton County, the Gold Star Mothers, often joined by Blue Star Mothers and Dads and local veterans groups, remember those lost in service to the country with a winter ceremony. Above, attending the 29th annual Lights of Memory and Wreath Service in 2009, are Bernice Conley, a Gold Star Mother, and Simone Marcotte, founder of the Blue Star Mothers and Dads. Below, Charles Smith, a Purple Heart recipient for his service in World War II, stands at attention, saluting his fallen comrades at the ceremony commemorating Pearl Harbor Day. (Both photographs by Andrew Wyatt, courtesy of the *Plattsburgh Press-Republican*.)

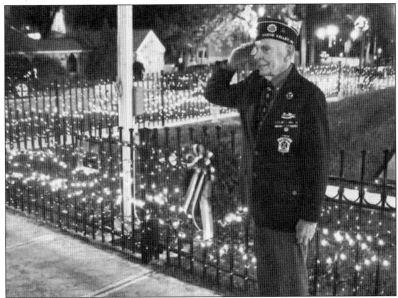

Unfortunately, as time has passed, more monuments to those lost to war and conflict have become necessary. In Grand Isle, the VFW and Vermont Department of Transportation joined forces to erect a flag and stone marker in honor of those who lost their lives on September 11, 2001. Although the initial flag was placed within 24 hours of the attacks, it was moved to a more permanent location in a 2010 ceremony.

In Richmond, Pfc. Adam J. Muller is remembered as "Richmond's Fallen Son." A gunner in the 10th Mountain Division, Muller was the 25th service member with Vermont ties to die in Iraq. A graduate of Mount Mansfield Union High School, he studied at Vermont Technical College and hoped to become a police officer.

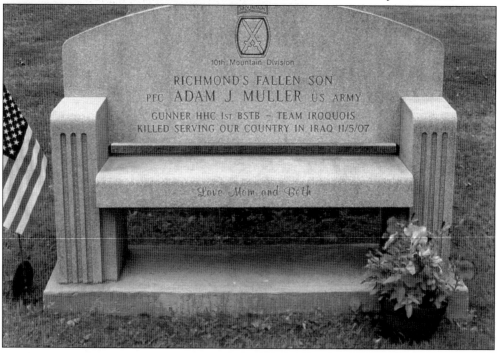

A nondescript marker near the administrative building of SUNY Plattsburgh remembers the students killed at Kent State in Ohio on May 4, 1970, and at Jackson State in Mississippi on May 15, 1970. Since 1971, the college has held a commemoration service every year. Organized by the Student Association, that first commemoration included a Festival of Life, which began with a quiet march of some 200 people, the planting of a spruce tree, and the installation of this plaque. Although tensions ran high during the Vietnam era, with protestors and Air Force personnel living in the same town, Plattsburgh did not witness violence like that seen in Ohio and Mississippi. Yet residents still remember.

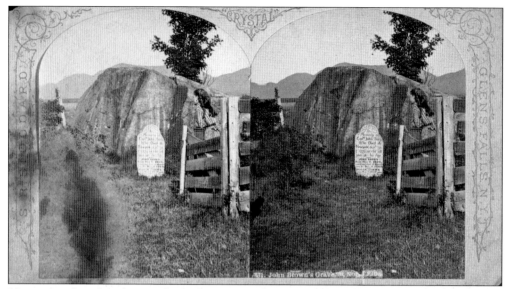

Most remembered for his attack on the Harper's Ferry Arsenal in 1859, abolitionist John Brown was buried in front of his North Elba home after he was tried and hanged later that same year. His farm is now a state historic site and his actions are remembered in several local monuments. In 1899, the remains of several followers who fought and died with him in Virginia were reinterred here.

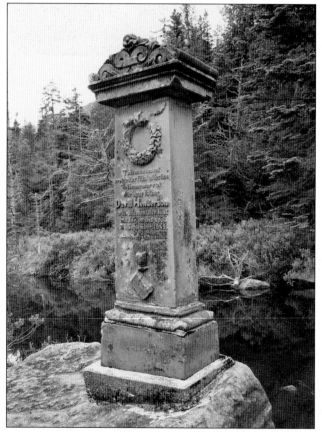

Among thousands of gravesites throughout the Champlain Valley, this monument "erected by filial affection to the memory of our dear father, David Henderson who accidentally lost his life on this spot" is particularly intriguing. Located on the shores of Calamity Pond, the monument remembers a man who hated guns and, while searching for potential iron mine sites in the Adirondacks, accidentally shot himself with a friend's weapon.

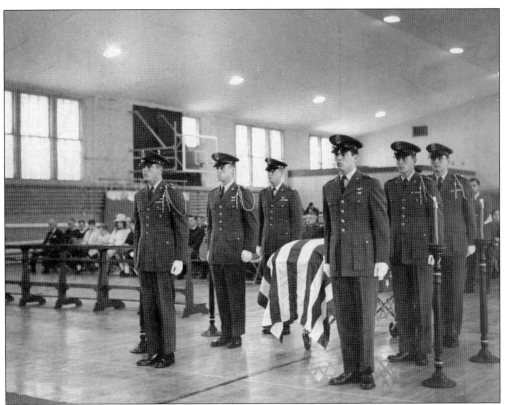

After Pres. John F. Kennedy was assassinated, the St. Michael's College ROTC performed a mock funeral for him on campus. Their ceremony gave life to the mourning that many in Vermont felt. Beyond this event, the president was remembered by many schools renamed in his honor. One of these, John F. Kennedy Elementary School in Winooski, continues to bear his name. (Courtesy of the Saint Michael's College Archives, Saint Michael's College, Colchester, Vermont.)

Paul P. Harris, great-grandson of James Rustin, who built this brick schoolhouse in 1818, would go on to found Rotary International, a service organization devoted to making the world better. Harris believed that his basic ideals, which became the framework for the Rotary— promoting peace, fighting disease, providing clean water, saving mothers and children, supporting education, growing local economies, and protecting the environment— were learned here.

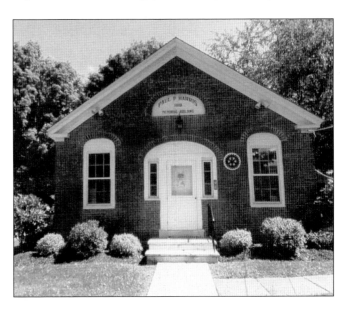

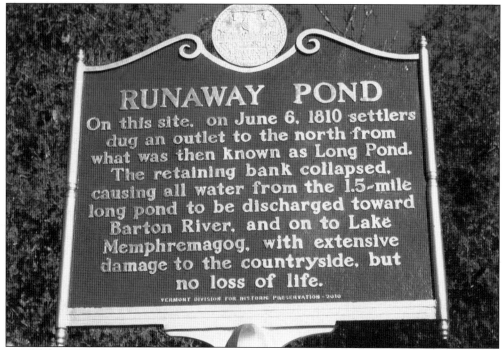

RUNAWAY POND

On this site, on June 6, 1810 settlers dug an outlet to the north from what was then known as Long Pond. The retaining bank collapsed, causing all water from the 1.5-mile long pond to be discharged toward Barton River, and on to Lake Memphremagog, with extensive damage to the countryside, but no loss of life.

VERMONT DIVISION FOR HISTORIC PRESERVATION - 2010

In 1810, trying to combat a long dry season, settlers in Glover, Wheelock, and Sheffield went to the northern end of Long Pond and started to dig a trench that would provide outlets to fuel the local mills. Unfortunately, their work brought them to a point where, underneath the hardpan, they discovered quicksand, which caused the water to "run away." Several hours later, the waters reached Lake Memphremagog.

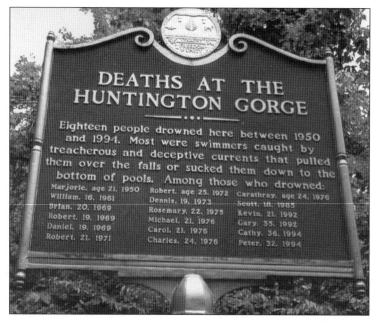

DEATHS AT THE HUNTINGTON GORGE

Eighteen people drowned here between 1950 and 1994. Most were swimmers caught by treacherous and deceptive currents that pulled them over the falls or sucked them down to the bottom of pools. Among those who drowned:

Marjorie, age 21, 1950	Robert, age 25, 1972	Carathray, age 24, 1976
William, 16, 1961	Dennis, 19, 1973	Scott, 18, 1985
Brian, 20, 1969	Rosemary, 22, 1975	Kevin, 21, 1992
Robert, 19, 1969	Michael, 21, 1976	Gary, 35, 1992
Daniel, 19, 1969	Carol, 21, 1976	Cathy, 36, 1994
Robert, 21, 1971	Charles, 24, 1976	Peter, 32, 1994

Huntington Gorge, with its spectacular pools and waterfalls, is one of the most beautiful places in Vermont and one of the deadliest. Formed through centuries of the river cutting through bedrock schist, the gorge quickly becomes a death trap during storms. More than two dozen people, including first responders trying to save others, have died at Huntington Gorge. They are remembered by this historic marker.

Local art teacher Jerry Seguin was known for his kindness, talent, and willingness to lend a hand. Seguin and his students participated in several outside art projects, including *The Read and Grow: Dream Garden Mural* on the Brinkerhoff Street side of the Plattsburgh Public Library. To remember him after his death, this tile leaf was installed below the mosaic.

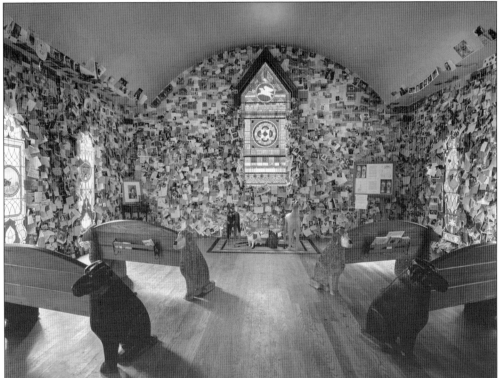

In 2000, Stephen Huneck created the Dog Chapel, welcoming "all creeds, all breeds, no dogmas allowed" to the St. Johnsbury site. With a variety of works of art, from carvings to stained glass windows, and memorials from post-it notes to personal photographs, the chapel has become a place to remember and to "celebrate the joy of living and the bond between dogs and their owners." (Photograph in Carol M. Highsmith's America Project in the Carol M. Highsmith Archive, Prints and Photographs Division, Library of Congress.)

BIBLIOGRAPHY

archive.org

Duffy, John J. *The Vermont Encyclopedia.* Hanover, NH: University Press of New England, 2003.

Eisenstadt, Peter R. *The Encyclopedia of New York State.* Syracuse, NY: Syracuse University Press, 2005.

Hemenway, Abby Maria. *Vermont Historical Gazetteer,* volumes 1–5. Burlington, VT: A.M. Hemenway, 1871.

Hill, Ralph Nading. *Lake Champlain: Key to Liberty.* Woodstock, VT: the Countryman Press, 1995.

Hurd, Dwight Hamilton. *History of Clinton and Franklin Counties.* New York, NY: J.W. Lewis & Co, 1880.

lcbp.org.

nyheritage.org

INDEX BY COUNTY

DISCOVER THOUSANDS OF LOCAL HISTORY BOOKS FEATURING MILLIONS OF VINTAGE IMAGES

Arcadia Publishing, the leading local history publisher in the United States, is committed to making history accessible and meaningful through publishing books that celebrate and preserve the heritage of America's people and places.

Find more books like this at
www.arcadiapublishing.com

Search for your hometown history, your old stomping grounds, and even your favorite sports team.